THE SLOVAK LIST

Series Editor: JULIA SHERWOOD

The Slovak List introduces works by writers from Slovakia, a country whose literature has so far remained in the shadow of its neighbours in Central Europe and not available to a wider readership. Launching with books by contemporary women authors, the series will feature work that reflects the diversity, innovation and variety of themes covered by Slovak writing today as well as in the recent past.

The Slovak List is supported by SLOLIA, the Centre for Information on Literature in Bratislava, Slovakia.

The Bonnet

Katarína Kucbelová

Translated by Julia and Peter Sherwood

LONDON NEW YORK CALCUTTA

Slovenské literárne centrum

This book was published with the financial support of
the SLOLIA Board, The Slovak Literary Centre.

Seagull Books, 2024

Originally published in Slovak as *Čepiec* (Slovart, 2019)
Original text © Katarína Kucbelová, 2019

Front cover image by Irena Blühová © Jaroslav Beránek, 2024
Map of Slovakia © Ivana Šáteková, 2024

First published in English translation by Seagull Books, 2024
English translation © Julia Sherwood and Peter Sherwood, 2024

ISBN 978 1 80309 352 9

British Library Cataloguing-in-Publication Data
A catalogue record for this book is available from the British Library.

Typeset by Seagull Books, Calcutta, India
Printed and bound in the USA by Integrated Books International

CONTENTS

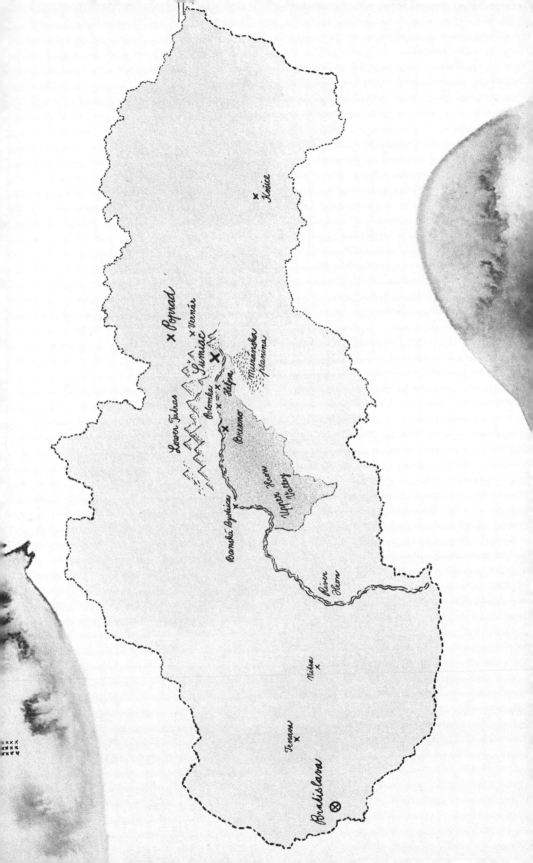

Košice

Poprad

Vernár

Šumiac

Lower Tatras

Malužina

Kolomba

Telpa

Muránska planina

Brezno

Banská Bystrica

Upper Hron Valley

River Hron

Nitra

Trnava

Bratislava

1.

What are you buying, Božena?

Do I detect mockery in this question? Božena is an old Roma woman.

Bread.

But you've got rolls already.

Božena is holding a sackful of rolls and crams in 40 more. As well as the bread. A determined, defensive look in her eyes.

I need to get something for Iľka and this small shop in a wooden cottage is my last chance. I pick up one of the two boxes of pralines and give Božena a smile, I'm glad she won't let the shop assistant rattle her. I try to remember the address. The Roma settlement begins just a few houses further down, Iľka lives next to it. I follow in the wake of a Roma family, two figures, the trail of a pram and a cigarette butt in the pristine snow.

Someone's waving to me from a window, that must be her. She's been waiting for me. It's going to be fine. One phone call was all it took. I'm coming this Friday. I'll be here. I did come and she was there, waiting, and addressed me as Betka. Later I became Danka as well as Radka.

But at four o'clock, she says, reminding me of what we agreed over the phone, she has to go to church for a requiem mass for her cousin who died just 40 days ago.

We have plenty of time.

We smile at each other as if this wasn't our first meeting. She ushers me into her house, she's just in a short-sleeved top. It was 10 below earlier this morning, 20 at the railway station in Poprad. Here in Šumiac they don't bother with the minus, they just say 20 when it's 20 below, and Iľka puts a sweater on top of her T-shirt.

This is the westernmost Ruthenian village. An ethnic Ruthenian enclave at the foot of Kráľova Hoľa, the mountain that is a national symbol of Slovakia, the country's 'roof'. But the cadences of Iľka's speech are not Ruthenian, they are of this area, the Upper Hron valley, and sound familiar to my ears, even though my grandmother grew up a little further south of here, on the northern side of the Poľana mountain range, the Vepor Mountains to be precise. The villages in the Low Tatras felt remote to her but I was drawn to them for some reason, even though we had no relatives there.

Not that there was anything wrong with the villages of the Low Tatras, it's just that my family had no ties to Osrblie, the village where my grandmother was born. We rarely ever visited the place and Grandma Gizela, who had moved to Banská Bystrica when she was 16 and later to Podbrezová and Zvolen, made sure that we grew up knowing next to nothing about Osrblie. The place was beyond the pale. So I will never make it to Osrblie, it's the end of the road, a valley in the mountains.

Iľka shows me into her kitchen heated by a stove. I loved the way my grandmother Gizela spoke, with its Slovakized German

words, typical of the Upper Hron valley. Gizela used them more often than her husband, because he never spoke. It will soon be clear that I am familiar with *piglajz*, the word for pig iron in these parts.

I'm getting used to Iľka's dialect, which is not quite how people speak in other parts of the Upper Hron valley or around Banská Bystrica. She uses the eastern Slovak form of 'to make', *zrobiť*, and often replaces her *e*'s with *o*'s. And the *d* at the end of the word *keď* is not palatalized, and reflexive pronouns are sometimes omitted.

It is a soft language all round, suitable for welcoming visitors. It's coming along.

I will call this woman Iľka.

This is the first time I hear this form of the name Helena. I'm familiar with the form Uľka, for Júlia. There were two Uľkas in my family—the Uľka from Kordíky and the Uľka from Malachov. I will call this woman Iľka, that's how Helenas are known in Šumiac, while Icka is the version used in Záhorie in western Slovakia and Ilona in Hungarian. Ilona Országhová, as the poet Hviezdoslav called his wife Elena. Mikuláš becomes Mikloš, Šimon becomes Siman. I might meet an Uľka here as well. There are two women left in Šumiac who still know how to make a bonnet.

There are none left in Telgárt and there used to be two in Vernár, but they, too, are gone.

At first she is the one who does all the talking. She asks virtually no questions, makes no attempt to probe this stranger she has let into her house. Does she trust me? I'm glad I don't have to talk. I don't explain why I'd like her to teach me to make a bonnet. The traditional, Šumiac variety, exactly as it should be, even though I don't have the first idea yet of what that is. I would find it hard to explain why: because I'm greatly tempted to learn something that will soon be extinct, curious to discover whether I can master this skill and why it so highly rated, that's all I can say.

It's actually an act of desperation, although I hope she doesn't notice. It's about letting something alien into my life. Anything. And hoping that it will stir something up. What that will be remains to be seen. And it's also curiosity, I want to find out what it feels like to be a woman who keeps her head covered and what it's like to live this kind of life.

I'd rather not admit to this good lady, who has never worn anything but traditional folk costume, that folklore actually leaves me cold. And that I am troubled by the way folk art has been presented, exploited and corrupted by regime after regime. I can't understand why everywhere in Slovakia we must have kolibas—log cabins—instead of restaurants; folksy wooden cottages for every purpose, by the motorways, amid prefab blocks of flats, in towns and villages alike. Koliba-style bus stops, former kindergartens turned into wooden cottages, pizzerias with their homogenized

corn-husk decor, even though half of this country is too cold for growing maize. A hairdresser's in a koliba, a koliba that's home to a Café Venezia.

Wooden cottages and log cabins are everywhere. They have swamped this country.

Conquered it by using valaškas, shepherds' hatchets, naturally. Wooden cottages in front of supermarkets, kolibas in town squares, on the roads, dotting the landscape, under my feet, between my teeth, wooden cottages and črpáks, the traditional carved wooden mugs, everywhere.

As I sit here listening to Iľka, I keep to myself the fact that I have no relatives outside of cities, that I had never spent time in the countryside when I was growing up, not even during school holidays, that I've never danced or sung in a folk ensemble, that I'm basically a creature of the city and that I don't get why in this country the mere mention of folklore—inviolable, inescapable, heart-warming—is enough to make people swoon. And yet, I have come here because I want to experience the real thing hands on, a parody won't do: I don't want a folkloristic case for my mobile, or a folk motif machine-embroidered on a hoodie or a tote of blueprint fabric, I haven't come here to embroider cross-stitch messages for the third millennium, I'm not after a processed universal folklore, clickbait folklore, instafolklore. I want to get beyond these superimposed layers. To feel and touch the real thing and then see what happens.

Fortunately, the drink she is pouring us is not the hard stuff, just Becherovka. Iľka is on lots of medications. She fusses over me, shows me pictures of her grandchildren, one a tenor in the opera choir, and her two sons, both car mechanics, one lives here with her, the other mostly in Germany. Her disabled husband died almost 15 years ago. Iľka is 10 years younger than my grandmother Gizela, she's nearly 80.

My late grandmother would have called her auntie.

That is how Grandma used to refer to the women who wore traditional costume all their life. But Grandma died over 10 years ago. In the photos taken in Osrblie, possibly right after the war—I'm glad to have at least those—Grandma is wearing a chequered town dress and contemporary hair-do and has a handbag over her arm. Her mother is wearing a headscarf and a kind of traditional folksy outfit, all black. Her sister Vilma and brother Milan are also dressed in town clothes. Iľka was just a child at the time.

Iľka has been teaching people for years, mostly weaving; she has taught her daughter-in-law too. But bonnets, once the obligatory headgear for married women, have become almost obsolete. And there are only a few women who still wear traditional costume and never leave the house bareheaded; Šumiac is a village that is renowned for this. There are also wedding bonnets, the only kind still being made today. It still happens now and then that people want to get married in folk costume.

I might be the only person who has ever come to her solely about a bonnet, and even that, to some degree, is just an excuse, a chance to spend time sitting alongside somebody, to be taught and give someone an opportunity to teach.

To take notes in my own hand. No recording. No filming.

I think we are both aware of this, even without having to spend long hours together. And I understand why, after coming home at the end of a day's work at the shop, she needed to sit at her loom for at least 10 minutes. I know that from my own experience.

And later I know what she means when she tells me that next time I'll have to come for longer, so I can spend at least one entire day with her, embroidering.

Meanwhile, under the window where Iľka was waiting for me, the TV set is blaring away. Her budgie, Igor, is doing its best to compete with the presenter; it's a contest, because television is nothing but competitions and cooking, cooking competitions and screaming matches, so loud that the signal breaks up in the doily-topped TV set.

I haven't told Iľka that I saw her on the TV, in a cookery show produced by my husband and am therefore not the first member of my family to visit her house. It's a coincidence that I discovered only later. I learnt from TV how to make dumplings Šumiac style. I wonder if Iľka is now a local celebrity: her appearance was very brief, she was showing a chef from Prague how to knit zapiastky, the wrist warmers that form part of the male traditional costume,

she was full of sparkling wit, not some bonnet-wearing cartoon character.

She seems more fragile in real life than she did four years ago on television. A shrewd woman with high social intelligence.

Not once did she bring this up.

2.

She can't wait for me to finish eating. She can hardly wait to spread all her stuff out on the table, but no rush. Bundles of head-scarves and fabrics are waiting for me on a bed by the table. All ready.

She undoes the knots and takes out individual parts of the bonnet one by one. I take pictures, try to draw the shapes, and she laughs at me, my clumsy sketches will be no use.

She shows me one completed bonnet, then a few more. I try to decide whether I like them, but they are not at all what I expected, though I hope I manage to hide my disappointment. The fabric is dreadful; nylon tulle with polyester lace as underlay for the embroidery. The colours run riot, of course, some almost glow neon, yellow and pink and green. Not a trace of restraint or moderation, far from it. The synthetic lace is interwoven with silver thread, and, to cap it all, the lace is not invariably white, but sometimes pink or turquoise.

Pink and turquoise.

There isn't a lot of difference between the folk costume worn in Šumiac and the neighbouring villages of Telgárt and Vernár. The same religion, the same kind of bonnet, the people are all Greek Catholic, originally Ruthenian. After a while I am able to distinguish the roses of Vernár from those of Šumiac. In Vernár and Telgárt, the women wear their kontík, top-knot, higher, nearer to the crown of the head. In villages further away, from Polomka to Brezno, the bonnet is quite different, Iľka calls theirs kapka. It is wider and a bit taller too, reminding me of the red-and-white ones from Heľpa.

I examine the inside of Iľka's sweat-soaked bonnet.

The tip of the bonnet, also known as kontík, has to be stiffened with cardboard to keep its shape.

The embroidery on the outside is loud: large, brightly coloured roses, predominantly an intense red and pink, but some are yellow and orange, and a few purple. I don't know what this technique is called, I haven't done much embroidering in my life, something else I'm not going to admit at this stage. What I didn't expect though is how slapdash the stitching is on the inside. I expected more perfection, but it turns out that a bonnet doesn't have to be perfect, since anything that is not visible when it's worn need not look good from every angle. Everyone does the best they can. She doesn't say what this refers to. The lining should be white cotton but that's not a must, any white fabric will do.

You can also use a piece of old tablecloth or bedsheet.

Now for the stiffening. You buy it from a pharmacy, Iľka often searches for the right word: starched gauze? bandage? Everyone used whatever they could get.

On Iľka's wedding day, she was given 14 bonnets by the girls in the village.

I'm trying to discover how far one is allowed to deviate from the standard fabrics and patterns. Take the Šumiac rose: it can vary from bonnet to bonnet in terms of its colour scheme, for example. The terms *tulle, nylon, polyester* haven't come up yet, that will come later when I go to buy supplies in Bratislava. As for the lace . . . why can't it be cotton? I have a good look and feel: the nylon lace reminds me of the trimming of a bra. Less firm, though. Of course, for me it is important to know what was used in the past. I'm sure this is the kind of material they used when Iľka was young, in the fifties or maybe sixties.

In the old days they presumably used bobbin lace. I remember Iľka mentioning the village of Špania Dolina, but not Brusno, oddly enough, even though that is closer and has a lacemaking tradition going even further back. Špania Dolina is a mining village only 10 kilometres from Banská Bystrica. When I was little, there would be a lacemaker sitting in front of almost every house, a bolster pillow before her, nimbly braiding threads on bobbins. It all looked extremely complicated. And that sound: the hypnotic click-clack of the wood.

Handicraft with background music. Even better.

How did these women get from sorting copper ore to making bobbin lace? Miners didn't farm and the women had to find something to do. I don't know much about folk costume and have assumed that the dainty, fluffy white lace bonnets and aprons embroidered in white were a speciality from Myjava in western Slovakia. The Šumiac women didn't make bobbin lace, at least not that Iľka can remember. And the colours too must have been different in the old days. No pink and turquoise ribbons or underlay.

The bonnets are embellished with glittery sequins and tiny beads. Each pattern is outlined with beads, which sometimes almost completely cover the embroidery, and ribbons covered in sequins in a variety of shapes hang from the kontík. Some bonnets have fringes with bigger beads ending in tiny wool pompoms in bright colours. They come out behind the ears, like oversized, multicoloured earrings imitating the stereotype image of Roma women's traditional dress.

Oringle is what Gizela would have called them.

So this is where 170 years of embellishing has got us. Since the abolition of serfdom. A profusion of ribbons sewn on the back of wedding bonnets, covering the bride's entire back, to stop her regretting right from her wedding day that no stranger will ever see her hair again.

I don't tell Iľka what it all reminds me of. In Šumiac they call ribbons *pantle*, from the Russian *bant*, pronounced with a soft *ľ*. Where did they pick up these trimmings from? The women of Polomka and Heľpa had them sent from America, for during the Great Depression more men left for America from these two villages than from anywhere else in the Upper Hron valley. Whatever I can't work out by myself, Iľka explains. Parcels with trimmings for bonnets kept arriving from America until well after the war, perhaps sent by children of the emigrants.

These days it is Ukrainian women that go from village to village setting up their stalls and selling haberdashery, but Iľka rarely goes out. Nor does she need to, she's well stocked up. She lets me have two of her beading needles.

They are the smallest needles I've ever seen.

She bought them years ago when she took the waters in Karlovy Vary. I picture Iľka on the promenade wearing her folk costume. Was it in the seventies? Or the eighties? The eye of one of the needles is smaller than the others' but Iľka can't see that. Soon I won't be able to either: I can't pass the needle through all the tiny beads anyway. In that case, you have to work the thread through the hole without it. This kind of work is underrated, she keeps emphasizing. I put my glass of Becherovka on the windowsill to make more room on the table.

The materials, the trimmings, the colours and especially the threads, which have to be as bright as possible—none of these bear the slightest resemblance to what I thought qualified as Slovak

folklore: things like linen, blueprint, bobbin lace, red-stitched embroidery, even black velvet perhaps, and at a stretch, red and white as the basic colours, alongside green, blue, yellow, as well as fur and wool as materials. Not this garishness, tawdriness, vulgarity, the kind of thing that people tend to associate with Gypsies, as many colours, trimmings, as much glitter as possible! But what do I know?

Though here in Šumiac, people set themselves apart from the Roma, and Roma women would never wear a bonnet anyway. Nevertheless, the bonnet is the most tangible manifestation of modesty: a married woman's head has to be covered, not a hair was allowed to stick out. Iľka remembers her mother tucking every last loose hair of hers under her bonnet.

On the TV a slow-motion clip from the eighties, an unbuttoned bodice, a swish of hair, fade-in, fade-out, and the doily, mustn't forget to lift the doily off the screen.

3.

Do the Roma go to church? To the Greek Catholic church in Šumiac? They do, and Iľka tried to indicate how immodest the Roma women are, not covering their heads and leaving their tresses exposed. She rolled her eyes, hinting at everything in her discreet manner. She must have been a woman of delicate charm in her younger days, she weighed all of 48 kilos, she tells me.

It seems that not even in the temple of God is there a chance of peaceful coexistence. They are loud, which annoys Iľka: sometimes in the middle of the service you have to put up with one of them leaping from one pew to another, or even across two. And besides, the church needs contributions for its upkeep, but the Roma don't contribute, she adds with resignation.

But when one of their own dies, they seem to expect a red carpet to be rolled out all the way from their settlement to the church.

Although I'm a guest of this modest woman I feel I need to let my hair down.

Iľka speaks in a somewhat halting way, perhaps because she is trying to avoid using the local dialect as far as possible when talking to me, or just because she speaks less these days and it takes her longer to recall individual words, although sometimes she can express herself very clearly. The Romas' presence in church is disruptive, in church you should be quiet, contemplative and think deeply about things, that's what we go there for.

And that's not something you can do if the Gypsies are leaping about the pews.

4.

My first impression is that the Roma are in the majority here. That's certainly the case in Telgárt. I noticed it straight away, as soon as I got on the bus. They all sat with me at the back, the middle door forming the dividing line. Two White women at the front: I seemed to be the only one ignoring the rules of segregation.

Coming back from Šumiac the bus passengers weren't segregated like this, but there were many more Roma on board. A beautiful young woman with a mournful husband, or father or brother, on her way home to the lower settlement in Telgárt— that's the smaller of the two, apparently there is another somewhere around here. A resigned, disdainful, absent gaze, I try hard to avoid looking at him. I let myself be lulled to sleep by the winter landscape.

When the Roma were buying their tickets, the driver didn't look them in the eye. *I'm not here with you*, he pretended just like the Roma girl. In Červená Skala, several toothless Roma women got on. The driver shut the doors on them just as they were boarding, only to open them again at once and start yelling. *The ladies are enjoying a chat instead of getting on, while I'm trying to heat the bus.* It lasted only a few seconds, he needed to let off a little steam. So things didn't blow up.

As Kráľova Hoľa appears, the sun comes out, the mountain is clearly visible from Šumiac. This is my first time in these parts. Brodsky's *beauty at low temperatures.*

Beauty at low temperatures is beauty.

5.

I'm embroidering white tulle, who would ever have thought. It's not so much the activity, but the material, the fabric that feels unpleasant to the touch, it's of a kind I've never associated with handicraft. This is supposed to be therapeutic?

I'm trying out a stitch that seems straightforward. It's fine to begin with but then the thread starts to fray; it's actually not that easy. Why is it fraying for me? Probably because I'm not doing it like Iľka who separates a single thread into three strands and threads it into the needle in such a way that she seems to be stitching with two threads.

I would prefer my stitch to be fuller, to use the whole thread, the bonnet needs to be stiffened anyway. Oh well, I'll separate the thread if I have to, but it bothers me, I'm annoyed that I haven't got the hang of it straight away, although I've never done as much as an inch of embroidering since I was little.

I'm just no good at embroidery. I can crochet, knit, sew a few simple things on my old GDR–made Veritas sewing machine, sew on a button, patch up something small. But that's about it.

Is it also to economize that you separate the thread? I inquire cautiously and Iľka doesn't deny it, it is one reason, of course, as that way the thread will last longer, but mainly because that's how you're supposed to do it.

The thread has to be separated.

She doesn't seem to have given any thought to why. You simply have to learn to stitch with the thread separated to stop it from fraying. This takes time, you have to learn how, she tells me encouragingly, and fetches a piglajz, a small coal iron, a heavy thing. She tells me to put the fabric down on the table and place the iron on top of it to hold it firm. How could they have done any ironing with this thing?

After returning home to Bratislava, I bought all the materials as well as a wooden embroidery hoop. Why doesn't Ilka have one even though she does so much embroidery? It is indeed coming along a little better with the iron on the table, although it's still not quite right. And in addition, the tulle is soft and keeps stretching.

This is what I need. To count one-millimetre-wide holes and focus to stop my thoughts from fraying, make that movement with my hand again and again, sit with my back straight, fall into the right rhythm to ensure the stitches are not too tight or too loose but sit evenly one next to the other. A smooth workflow, a smooth result.

6.

It was dreadful.

This is how she begins to talk about her life.

17

She was the second daughter-in-law to come into her husband's family, one more came after her. Her husband was one of three brothers.

She returned to this topic several times in the course of my visits. The memories of old folks: sometimes the same words or sentences would be repeated months later, sometimes a fresh detail would emerge, a new fact or another angle. And it was no accident that this was the first episode in her life that she wanted to talk about, since it was also the worst, although another one would follow later.

Three couples, parents and children. Her first son was born in 1959, everyone living in one or two dark rooms, in a part of the country where it's cold almost all year around. But there were several stories of banishment to the East in her family: things could always be worse. There weren't enough beds. Twelve people in a single wooden cottage. The bed Iľka and her husband slept on was in the pantry.

Earthen floors? No, wooden floors, which had to be scrubbed every Saturday. It wasn't that long ago; in fact, that's what it's like in the Roma settlements even today. Here we go again, she has started talking about a Roma family and what their house was like without me bringing it up. Iľka tells me about a *Gypsy* family in Šumiac that kept expanding, with each room housing a complete large family, a new generation. In the end they made a separate outside door for each room. In Iľka's case probably not even a separate entrance would have helped. I wonder if she sees the similarity here, why else would she have brought up the Roma family?

And then there was the smallholding, because in Šumiac the collective farm wasn't set up until the seventies. And that, it turn, meant delivering quotas.

Twenty years.

Iľka rattles off the exact number of kilograms of meat, litres of milk and amounts of everything they had to produce every year and hand over to the state, because in this neck of the woods, quotas were the postwar reality, with enforced nationalization coming only after a long delay.

It seems that everything in these parts has to be viewed through the lens of this time lag. Even today. Quotas as a lifelong trauma. Quotas from the age of 10 to 30-something. I have no idea what these figures mean in concrete terms, so I just ask if there was anything left for them. Almost nothing, she replies.

What do I find more surprising: this situation or the fact that Iľka trusts me?

Iľka and her husband eventually managed to buy a house of their own, the one we're in now, and to renovate it later. But to do that they needed money and even though Iľka had a young child (I'm not sure if she's referring to her first son or her second, more likely the first), she took a job in the local shop. From her description it could well be the one where I met Božena. Every morning she would push the pram with her baby to the far end of the

village and leave the boy with her parents for the day. Work started at six, the streets were not asphalted, of course, and the wheels on the old prams were very small. A sequence of movements and details that make seemingly similar experiences incommensurable.

Fifteen years after the collective farm was established, communism collapsed, the Velvet Revolution broke out and the collective farms slowly began to fall apart, but by then she had reached retirement age. Her husband lasted another fifteen years and now Iľka has been a widow for as long again.

As for the Roma, they've been here for a long time. Iľka remembers them as having plenty of time to spare because they didn't work. She sees her own life solely in terms of work. It's the stereotype of the lazy Roma and the unjust state that encouraged the Roma to shun work while depriving Iľka and her family of everything that it could, until what little was left of their smallholding was incorporated into the collective farm.

7.

Fuck off, they said.

It startled me to hear her say the word. Iľka was just telling me about something that occurred at the Teplička spring where she goes every year at Epiphany to draw water which is consecrated there on the spot: *down here, by the Patkaň bridge.*

An old custom, a relic of the strict religiosity of old, when there was a rule for everything. Over the Christmas holidays, the colour of baršon—the velvet headscarf that had to be tied over the bonnet in a particular way—would change, just like the covering of the bride's head. On the first Sunday after a wedding the baršon was white, on the second it was yellow, and pink on the third, otherwise it was black velvet. Iľka has shown me a purple and burgundy baršon, something to do with Christmas if I remember right.

Fuck off is what some young Roma men said to Iľka by the spring after she told them off for trampling all over it and making the spring muddy. The young Roma are quite different from the older ones, they show no respect, she explains.

I don't know what she means by saying that the Roma should show respect. I hope she means that children should show respect for their elders, rather than respect for White people. But I'd rather not ask.

In fact, this is the only actual conflict she mentions, apart from the time some timber was stolen from her garden two years ago. What surprised me, though, was that in Telgárt and Šumiac the Roma said hello to me when they passed me in the street, as no one had said hello to me in these villages before.

8.

I read about something that occurred in Klčovany, a village near Trnava. It also had to do with a spring. It happened in 1942, during the Second World War. Six Roma families were living on the edge of the village, close to a spring, and the locals didn't like that, since the whole village drew their water from it. The Roma were accused of polluting the spring and the locals wanted them shunted to a more remote part of the village. The Roma refused to move because the municipality would not cover the cost from its budget. Basically, this was an attempt to expel them by applying indirect pressure, even though they were working people who simply happened to live in the village, or, in other words: however simply, they were living there. Nevertheless, they were accused of begging, even eating carrion.

And the Roma kids were said to put lice into the hair of the White children at school.

Another argument went that the Roma were hampering the development of a local tourist industry. In 1942, mind, at the time of the transports. I wonder if they, too, ended up in the camps. There is no tourism in that area to this day and probably never will be, as a nuclear power station has since been built there.

The worst anti-Roma pogrom took place some 40 kilometres further away, in the village of Pobedim, near Piešťany. In the early autumn of 1928, 50 White men attacked an area where some 100

Roma lived, dubbed the *Gypsy camp* by the locals. They arrived armed with whatever was at hand, some carrying guns, some iron bars, others stones that they hurled at the windows to lure the Roma from their homes. The first to be shot dead was a man standing in his doorway; his wife and child who were hiding inside were clubbed to death.

A further three Roma were killed as they fled.

In the course of the investigation the survivors pointed the finger at the local peasants, and some claimed to have heard the mayor's voice. Twenty-one men were detained, of whom the Roma were able to identify only ten, as everything happened under the cover of darkness and the village people provided one another with alibis and claimed that the men had spent the entire night at a dance and that no one had heard any shots or screaming, nor had their families.

In the end, ten men were convicted and given a maximum sentence of two and a half years. They all appealed, and none served more than eighteen months. The investigation cast light on events that had preceded the pogrom. A peasant had injured two Roma women in the field, firing at them from a shotgun out of the blue.

Sometime later, when a fire broke out in that field, it was seen as the Romas' revenge. There was no proof, in fact quite the contrary: the chief of the fire brigade complained in court that the peasants prevented him from putting the fire out. A few bales

of straw had burnt down, nothing more. In the course of the trial every stereotype in the book got an airing, the same ones we can imagine hearing today: the Roma are lazy, they are shirkers, cheats, thieves and liars, they terrorize the locals and live in shacks. The defence lawyer portrayed the defendants as law-abiding citizens, paterfamilias who pay their taxes and contribute to the running of the village, decent citizens versus parasites. The Roma were blacksmiths making horseshoes and chains, as well as bricks, some earned their living as musicians or farm labourers or worked on the railways. They all held down jobs but that didn't save them from a *final solution*.

In 1934 the village decided that the Roma should be relocated after the local people had set their sights on the land they owned, but the authorities said no.

In 1942, the peasants finally had their way and the Roma were deported to labour camps.

9.

There are more Roma in Šumiac now than in the past, which is particularly striking in the local schools. In one of the classes in the Šumiac kindergarten, there is just one White child and in the other there are two. The Greek Catholic priest in Telgárt drives his five children to school in Heľpa, three villages further away.

Iľka thinks the Roma are beyond help. At one point the municipal authorities had portacabins with bunk beds delivered. The next day the Roma put the bunk beds up for sale, fearing that their children might fall off, so they preferred to let them sleep on the floor. Iľka has no sympathy with this sort of thing, although she does try to avoid tarring everyone with the same brush.

I know there are some good Gypsies too.

She shows some remorse without any prompting from me when she recounts what she saw in hospital one day as she accompanied her husband for a check-up. A local Roma she knew was brought in, he must have had a stroke or a heart attack and was in a terrible state. Tears welled up in her eyes as she told me this, the only time I saw her tear up, the image coming back to her with great clarity even though this must have happened at least 15 years ago. Yet, when she spoke about parts of a bonnet that were fully embroidered and just waiting to be sewn together, she mentioned that the embroidery was done by a woman from Vernár or Telgárt who was no longer with us. She showed no emotion when she said this.

10.

The moment I laid my eyes on Iľka's house I thought there was something touching about it.

About her living quarters on the ground floor, to be precise. Two rooms, a kitchen and a bedroom: that's Iľka's home, the lino and the kitchen slightly more recent, some holy pictures, the Ten Commandments on the wall, a TV, three large wardrobes facing a double bed, a chair and a small table under the window where Iľka does her sewing. Igor's cage, a Singer sewing machine.

She keeps fussing over me, keen to make me feel at home. And I do feel at home—were I uncomfortable in her place I would have sensed it straight away and this project of mine would have come to nothing. She makes me eat: if I turn the soup down it means her grandson won't get married. I couldn't do that to the tenor, obviously.

The tenor must get married.

The tenor's mother comes in and asks if I have tried on any of the bonnets yet. I haven't. And then it happens, the wedding bonnet ceremony, right here in Iľka's kitchen. I remain seated while the two women, Iľka and her daughter-in-law, fit me with a bonnet.

I've tied my top knot slightly higher so that it fits into the kontík, Iľka has taken out some hair clips from her own bonnet

and handed them to her daughter-in-law who pins my hair down at the sides and the top. Iĺka took off her bonnet to show me how she tied her hair: there's a special way of doing it, of course, there are rules for everything, she ties hers with a shoelace but in such a way that the plait forms a kind of bowknot on the crown of her head, presumably to keep both corners of the bonnet in place. I recall seeing some unusual metal clips in a book on traditional folk costume and now put two and two together: that's how women wore their hair and the metal clips were used to keep the bonnet in shape back in the old days, when cardboard was not available and there was less hair, or less and less hair.

Iĺka and her daughter-in-law straighten out the pantle, the ribbons at the back, adjust the pompom fringes behind my ears, oringle, except that these are not circular. The women are as excited as if this was a real wedding bonnet ceremony, and there is also the pleasant thrill of the unknown, not least on my part: I've become a newly married woman, I'm *under the bonnet*, as they say, and I don't know what lies ahead, come evening I will go to bed with a man I don't know, echoes of ceremony arising from excessive cooperation, for surely I could have put the bonnet on myself.

It's a good fit, the bonnet clasps my head in a strange way, I feel different wearing it. They compliment me, saying that the bonnet suits me. *You are as pretty as a rose*, isn't that what people used to say to the bride? It may suit me, but wait a minute, am I even married? I am but I don't dare ask what would happen had we gone through with the wedding-bonnet ceremony had I been

unmarried. Maybe it would prevent me from ever marrying, just like the tenor who couldn't marry if I hadn't eaten Iľka's soup.

The tenor and I would be condemned to spending the rest of our lives roaming the bars of Bratislava, me and the tenor with his voice of an eternal prince, and neither of us would ever find a partner.

I've been bonneted, fed and married, that is to say, my life is sorted, as Iľka says, thank goodness, no dangers looming, all that matters is that the bonnet stays in place. You can even dance with a bonnet on. Dance wildly.

That's allowed.

But the tenor must get married.

11.

What if Iľka leaves me

with my bonnet incomplete? That's what flashed through my head as I held in my hand the roses stitched by the dead embroiderer from Telgárt that had yet to be sewn onto the bonnet-to-be.

I'm haunted by the dreadful thought that she might die at any moment, even though I've spent only a few, admittedly intense, hours here. I couldn't take another unfinished chapter after Gizela, that's not what I've come here for. I must make this bonnet, finish

the job, master the technique. I will stitch Šumiac roses onto the ghastly synthetic lace, I will fit together all the pieces, sew the bonnet up and embellish it using the needle from Karlovy Vary, I will give it new life, I will fill it. But to do that I need something tangible, an object I have made with my own hands, that's the only way for me to grasp it.

What will I recapture by doing this, what will I resolve, ensure that it's put it in its rightful place? What is certain to endure? I can do this by being with her, by being able to put it all together, sew it up, embellish it and heal it. Perhaps. And at the end there will be a bonnet, a useless bonnet. Something, anything, that's the only way I can do it.

We've had a nice time, haven't we?

She asks when I tell her I have to go. Yes, we've had a nice time, I've had a nice time. We agree that I will come again and spend all day sitting with her, embroidering. As she is walking me to the bus stop, my husband rings: he has tried to reach me several times but I didn't pick up. No need to worry, I'm in Šumiac, not in the Donbas and besides, he has been here and knows where I am and what this place is like, having shot an entire episode of his cooking show here. The locals were told to put on their folk costume, to make Šumiac dumplings and take a ride down Kráľova Hoľa on krne, the traditional wooden sledges. Not a single Roma appeared in the entire episode shot in Šumiac, a perfect illusion for the Slovaks, a fake tradition.

Iľka asks me to tell him that my visit was entirely above board, she can vouch for that. She sees things quite differently: there's this married woman wandering around Slovakia, so it's only natural for her husband to be concerned about the company she keeps. It's only right and proper for him to check on what she's been up to.

12.

The shop is teeming with Roma. In Telgárt they definitely out-number the White folk, by some 900 to 600. The small settlement I saw by the roadside was apparently just a fraction of the whole, with another, bigger settlement at the foot of Kráľova Hoľa towards Šumiac as the crow flies. In Šumiac the figure is still 2 to 1 in favour of the Whites, with the Roma numbering some 400.

A pensioner and I are the only White people in the grocer's apart from the shop assistant who shouts at the Roma girls to shut the door as they leave. She has put the heating on, like the bus driver. The Roma women keep dashing in and out, and the shop assistant is complaining to the pensioner about the latest thing that has gone missing. The Roma man says they're swiping some milk, but no one hears him, so he turns to me instead, asking if I'm from these parts. His question makes me smile, that remains to be seen, my roots are up in the air, but I just respond with a brief no while he explains that I look like someone he knows.

I look like a woman who runs a boarding house here.

In Pavel Hrúz's collection *Bread and Bushes*, a hymn to the language of Banská Bystrica, there is a story about the neighbourhood adjoining tennis courts in a park then still named after Lenin. He describes the neighbourhood as being long in the tooth. He is right, I should know, I spent part of my childhood there, at my grandparents' house.

You won't see a child anywhere around here kicking at the branches that have fallen off the ancient plane trees overnight, or splashing around in the puddles that dribble from the park keeper's relic of a pump all the way down to the road.

I am the child who isn't there.

Whether at my grandparents' house, at my mother's, or anywhere else, I've been fixated on plane trees all my life. I remember the puddle by the tennis courts that would never dry out, I remember being knee-deep in yellow leaves, I remember the drag brush for the clay courts and the high wall it used to be propped up against, but I don't remember the old park keeper. I'm the child who isn't there, the child without any roots, so I could just as well be a woman who runs a boarding house in Telgárt or Šumiac.

In Telgárt, too, I see Roma everywhere, they all say hello to me as if I were their schoolteacher. In the woods I run into a group of men who must be out collecting firewood as they're pulling a piece of plywood on a string, still empty.

I pass two children without their parents, one without a hat, the other without a winter jacket, pulling a makeshift sledge. It's an identical piece of plywood, only with a couple of runners.

Behind them there walks another Roma, a good-looking man, not pulling anything, he strolls at a leisurely pace taking slow drags on his cigarette. He's out walking, like me, headed nowhere in particular. He has a bushy beard and melancholy eyes. He wouldn't be out of place in any café in Bratislava. He says hello, quietly.

13.

The book called *Between the Waters* doesn't exist.

It's a work that doesn't feature in Klára Jarunková's bibliography. And it wasn't her official debut, as Iľka seems to think. Nor does the Villa Maliter in Červená Skala, Klára Jarunková's birthplace, exist any longer, which is news to me.

Nor are there any nuns left in Červená Skala, or the annual fair. What is left is the turn-off to Muráň from Route 66, the arterial highway of the Upper Hron valley linking Banská Bystrica with Poprad, and a railway station on the Banská Bystrica—Margecany line, via the Slovak Paradise National Park. And there's the river Hron, here still a small stream, as well as another stream, and the few trees that stood by the former villa.

All her life Iľka has been looking for a book entitled *Between the Waters*, but couldn't find it anywhere, in no second-hand bookshop or library.

Not even in Brezno.

And yet, Iľka remembers the book from her schooldays, as clearly as she remembers Klára Jarunková as a young writer after the war who had just published her first book. The names in the book are of real people, and Iľka feels that it contains all those things that have slipped away from her forever, the colours of a childhood beyond the reach of memory in her old age.

Because unlike Klára, Iľka no longer remembers the Bulgarian Czar Ferdinand Maximilian Karl Leopold Maria of Saxe-Coburg-Gotha.

Klára remembers him arriving in Červená Skala by way of Predná Hora, perhaps in his automobile. The Bulgarian king, who spoke 18 languages and loved the Muráň region. So legend has it.

She also remembers that her brother tore his first suit of clothes during this visit.

14.

Šumiac and Telgárt get a mention on the news.

The Ministry of the Interior has drawn up a list of villages where there has been an increase in crime among socially marginalized groups. That is dog-whistle language for *Roma criminality*. The list includes several villages with Roma settlements. It is not clear how they were selected, as the local mayors insist there are no problems. The locals say the same things on camera as Iľka: as a matter of fact, only the bad-mannered children are disruptive. More police and more CCTV cameras are to be deployed in the villages concerned. An open invitation to neo-Nazis.

Seen from a distance the lower settlement in Telgárt looks as if it came straight from a painting by Bruegel or Avercamp.

Children are playing ice hockey on a small patch of cleared ground, which as I approach I see is nothing but trampled-down snow. They can't afford ice skates and play with a small ball, a huddle of supporters around them, smoke billows from the chimneys.

Both villages are deserted. Nothing stirs until you reach the settlement, where suddenly there are people in the streets, comings and goings.

But I don't know anything about them, I have no idea who is on speaking terms with whom in the settlement, what the hierarchy is.

There are other villages in these parts that at first sight all seem deserted. In the woods, White boys are holding exercises: there are Nazi symbols and music, slogans from the wartime Slovak republic, cards wishing everyone a White Christmas. The complete extremist package with the nationalist regional governor at the top.

I listen to the stories. About the boy who abandoned his university studies in Bratislava and returned to his home village to look after his sick mother, as she had no one except him and he had no one but her. Now he works as a labourer for the minimum wage and is convinced that things will stay like this forever, and he may well be right. The only thing he has apart from his mother are his mates, and they have a plan.

A plan to defend the nation: a White winter, spring, summer and autumn.

15.

Grandma's sister Vilma lived in Brezno, but we never visited her there, only in Osrblie, where she lived earlier. I could still find my way to her house. Vilma's husband hanged himself, and later so did her son.

Vilma was the favourite and adored child, perhaps even more of a favourite than their brother. This made Gizela unhappy, it defined her life, and later my mother's and mine as well.

I never met Grandma's brother. I don't know when he died, whether he married and had any children, where he lived, or what he did for a living. How is that even possible? His name was Milan.

In Banská Bystrica, they say that civilization ends in Brezno.

Vienna's Landstrasse is where Asia begins, Metternich used to say, but that was in Napoleon's time. He also said: Der Balkan beginnt am Rennweg, because that was where he lived, on the road to Budapest.

The West ends in Strasbourg, that's another variant. Or: the provinces begin on the far side of the horse railway tracks, as people in Bratislava would say, although by the time the one and only horse railway opened in Slovakia, it was being replaced by the steam engine in the more developed parts of the world. East of Bratislava there are just the provinces, as they say to this day. But there is another way of looking at it: the East begins on the other side of the Telgárt tunnel, that's where the character of the landscape changes, it's the beginning of the karst, the Slovak Paradise, Slovakia's east. The railway line Banská Bystrica–Červená Skala–Margecany. Or yet another angle: the East begins on the far side of the Soroška Pass in the south and the Branisko Hill in the north. And there are dozens of other lines, for example Petersburg–Katyń–Kyiv–Odessa–Istanbul.

Vilma, my grandmother Gizela's sister, had a daughter who lived in Brezno. I think her name was Ľuba and I seem to remember that she had a daughter called Zuzana, who was about my age. Then there was another man, Ľuba's brother probably, I was surprised that his death came as such a blow to Grandma: she heard the news shortly before she herself died. I couldn't work it out, as she had hardly ever mentioned him before.

I barely knew any of my relatives from the Upper Hron valley who turned up for my grandfather's funeral. And I have no recollection of Gizela's funeral even though that was many years later. Or rather, I remember a metre-long section of the rocky path in the cemetery, and how my light shoes were not right for the weather.

Waiting for the bus in Brezno I overhear two women listing the places where their children live: Prague, Plzeň, the further away, the happier the mother and the greater her friend's approval.

That was also how Iľka started a conversation with me: one of her sons in Munich, granddaughters in Trnava and Bystrica, a grandson in Bratislava. The key thing is to leave, preferably heading for civilization, but just going away is enough. Away. Almost always westwards.

I don't know whether I'm coming or going.

I'm convinced that it won't matter in the end. Below the surface, everything is starting to change. Greater depth brings greater intensity. All that will remain in the end will be a bonnet and a book. A bonnet I won't wear, a book I won't read.

16.

There is no bread or rolls to be had anywhere in Šumiac. One of the shops has closed, everything is sold out in the other, like under communism. I haven't been to this shop before, the narrow aisle has been monopolized by two men sipping some spirit from miniatures. I spot a tiled stove at the far end, that's where I'd prefer to hole up.

There's a fire crackling near the checkout and the fruit and vegetable shelves.

The village square in front of the school is busy, public works, a White teacher and a few children, all the younger ones are Roma. Winter is on its way out but it will be back, there is ice everywhere, brown patches on the slopes. I stumble several times and once even yell out. A woman in folk costume ahead of me stops and waits and we exchange a few words about the ice. I help her get to her house, or rather, she helps me. There is just enough time for her to list all the places her children and grandchildren have gone, I forget their names, they live far away, but we've made it home without falling over.

Iľka is waiting for me: *where have you been gallivanting?* As if there was nothing special about the fact that I had just made another five-hour trip from Bratislava.

Even now I wouldn't be able to explain why. My hunch is that it's to do with Gizela but it's too soon for me to tell her that, and in any case I wouldn't know how to.

I will embroider everything into the bonnet, a tongueless Philomela, and once I'm transformed into a budgie, I will flit from one of the Jesus pictures on the wall to the next, along with Igor, from the Ten Commandments to Ilka's wedding photographs, to the tiled stove that no longer needs to be turned on.

I wouldn't be able to write without embroidering.

I don't know if I would start embroidering without this book.

So here I am again, but nothing surprises Ilka, of course I'm here, and no matter that I didn't practise at home, I have brought the supplies. Ilka can't wait to see what I bought but insists that first I must have a bite to eat, we'll have some tea and I have to taste one of her pastries, she'll warm them up in the microwave which she doesn't use otherwise. Then we must try one of her neighbour's pies: she explains that whenever they bake, they share with their neighbours, something else Gizela also used to do.

She asks if my parents know about this. A good question, not obvious but direct. She suspects that what I am here for is not just the embroidery. I feel like a 15 year old.

Do your parents know your whereabouts?

You haven't by any chance, have you, run away from home, taking the train from Banská Bystrica to Margecany, getting off at Červená Skala, at the far end of the Low Tatras, under Kráľova Hoľa, before the Telgárt loop, the Telgárt tunnel?

Does your mother know you're here?

Gizela would ask me when I ran away from home by climbing out of my window at night, and rang her bell.

My father is no longer alive and my mother lives in Banská Bystrica, we don't see much of each other, I reply briefly but truthfully, it's as much as I can manage at this moment. These things happen, I try to add by way of excuse or explanation, but she doesn't ask any questions and once again I'm astonished by how tactful she is.

17.

The TV is not on this time, she is listening to a radio programme for ethnic minorities instead. It's a broadcast for the Ruthenians, so she does understand the language after all even though otherwise she doesn't identify as a Ruthenian: the religion is all that's left, they assimilated a long time ago and she can't really explain why it appeals to her.

She can't wait to see what I've bought. She has spread on the table a baršon of red velvet that she is embroidering with white thread while I unpack the supplies I brought: some white tulle, white lace interwoven with silver thread and a few skeins of mouliné thread, a wooden embroidery hoop and some single-sided interfacing. And a few needles I found at home.

Apart from the interfacing, which I bought by way of experiment, I got everything wrong. The interfacing is all right for stiffening, anything that will make the bonnet more rigid will do.

The tulle ought to do, but this particular type is too soft, we can't use it widthways because the holes are not slanted the way they should be. And I need at least half a metre if I want the bonnet's hem to be embroidered.

The embroidery hoop is too small and the lace won't do either, it's too delicate, Iľka uses an old wedding veil for this purpose. If the thread frays, which is bound to happen to me, the lace would tear.

And, last but not least, the thread, the mouliné, is the wrong kind.

What we need is cordonnet, how could I have forgotten?

Cordonnet, a thread that used to be made in Šumperk Factory No. 17 in Svit, or Moravská Třebová, for 3.80 Czechoslovak crowns per ball, cordonnet or lace thread, Iľka adds, *we call it lacet*, that may be why I forgot, two new words were too much for me.

Where did they get the word *lacet* from? Perhaps from some yarn that women in Heľpa and Pohorelá were sent from America. *Lacet* may originally have been used for lace, maybe it had the English word *lace* on the spool and it caught on, like the American profanity *sanovabič*, or the Russian *yobtimať*, motherfucker, which Iľka's grandfather had brought from Siberia where the temperature would often plummet to 40 below, with no toilets and urine freezing in the air, turning into a thread of ice.

Iľka pulls out boxes filled with lacet of every conceivable colour. She has loads of it, all made under communism or immediately after its fall; she says she can give me more thread than I will ever need. There's certainly more than she will ever need. I recall something she said the first time on the phone: I just hope the craft doesn't die out, come and you'll see. I've come and I've seen.

Enough thread bought for the old Czechoslovak currency to see her through several generations.

We start embroidering the edge that frames the wearer's face, stitching a simple zig-zag pattern in five colours, generally blue, yellow, light blue, red and burgundy. The first time I saw it, this was the part of the bonnet that struck me as the most exotic, the colour scheme and the patterns felt sort of Mexican or South American. But one mustn't speak of Slovak folk costume without praising it for being exceptional and distinctive. In Slovakia, the notion that its traditional folk dress is unique cannot be challenged. It now seems to me that everything is a lot more complicated

than I thought. Ilka is stitching, our heads touch. This is the first time in my life I've felt I need glasses.

Our closeness soothes and whispers. Perhaps just sitting next to someone who is teaching me to make something is soothing, the transmission of a manual skill, the repetitive movements, the fleeting touches.

The holes in my tulle are slightly larger so we try not to separate the thread, but before long I realize that it works only when the thread is separated, although it then tends to fray even more. When I get a small section right, I can see that it is managing to hold its shape as the stitches sit next to one another more evenly.

Ilka even corrects my posture so that I don't get a pain in my back. Like everything she does, she does this quite naturally.

When we remain silent it all comes along fine.

The more we talk the more the thread frays, for both of us.

She puts down the piece she's been working on. When it isn't coming along, it's time to stop.

18.

I don't know how we ended up discussing theatre though I do remember how we got to the psychologist: when I asked her about Igor, she said it was the psychologist who gave her the first budgie. Igor is one of its descendants.

She also mentioned the psychologist the last time I was here, though this didn't seem crucial at the time: just that she was a vegetarian, like me.

They met in Podbrezová, when Iľka had some problems, and they have been friends for many years now. Iľka taught the psychologist to weave and gave her a loom because, as Iľka said, the psychologist had also been through enough to weave into rugs or cotton cloth.

Iľka had performed with the local amateur theatre in Šumiac for most of her life. She was cast as an old woman even when she was young, because all the other girls wanted to look pretty and dolled up and she was the only one who didn't care.

As she has always been old, people were later surprised that she hadn't changed at all. She laughs as she tells me this.

An old woman all my life.

Now she has a different role to play, although she doesn't know it yet, playing that of my grandmother. Though I don't know when and how to tell her this. Or whether to tell her at all.

She used to enjoy acting, more than that, she needed it, but the problem was that her husband sometimes didn't let her go. *You go to that rehearsal and you're not coming back into the house.* As she quotes her husband, who's been dead for 15 years, she makes it sound like a line from a play, an old woman's line, one who hasn't changed much in 40 years. Her husband would crash out after a few drinks, he couldn't take much, and then she was free to go.

So why did she give it up? She could still be playing old women if the repertoire had stayed the same. She can recite entire passages from plays she was in half a century ago. She gave it up after falling ill. I ask what happened and she replies matter-of-factly: burnout syndrome.

This woman in folk costume, who had never worn town clothes because she lived and worked all her life in the same village in the mountains, in this backward region that has always lagged at least two decades behind, this woman burnt out.

Looking back I'm not sure exactly how this conversation went, I might have suggested that the reason she burnt out was to do with what she went through as a young woman in the fifties, the quotas, and a life without any privacy: four families sharing one wooden cottage, three daughters-in-law and their children in a single house, a house with wooden floors, but of course she knows all that already.

The root cause of everything that happened to Iľka when she was around 50 dates back to 30 years earlier. In fact, nothing actually happened, except that she could go on no longer.

The sound of bottles rattling in a crate was enough to make Iľka go to pieces.

Ordinary shop noises, paralysing anxiety. With me it's the other way around: village shops put me in a carefree mood, I grew up in one, that was where Gizela worked too. For me small shops mean Gizela, the one fixed point in my early life.

Gizela did the same job as Iľka. After she got married. Before that she worked in a kindergarten, which was actually an orphanage for newborns and toddlers.

But the last time I came to see Iľka, I learnt that her life in the fifties had been rather different. Her father had refused to join the Communist Party just as young Iľka was about to start secondary school, and she needed support from the state, some kind of scholarship, otherwise the family couldn't have afforded to send her there.

Her father was punished by the Party, she didn't get the scholarship, and that was the end of her education.

Her older sister was getting married at the time, and the money was needed for her wedding and trousseau, so Iľka had to give up school. A combination of unfortunate circumstances, with no way back.

She started working in the shop, and then they married her off. She didn't want that either. This was the second half of the twentieth century, yet this is what happened to her: a boy from a better-off family picked her out and off she went.

When speaking about her parents, my grandmother would still refer to them in the old, respectful way, using the third-person plural, and even my mother did, when speaking about them: *My father-in-law, they came back from America, they had left another family there.* Or: *My father, they said that my brother would be the only one to go to university. But studying was not his thing.*

Ilka still speaks this way: *My father, they worked in the woods, they wanted at least to make sure that their daughters married well.*

She cried a lot, she didn't want to stay in the village, her story could have been a total cliche if she hadn't ended up as a burnout in folk costume, quite a different narrative from the one pushed by socialist realism: of the poor working people who had a hard life but wouldn't let it break them, it taught them humility, made them resilient, and they went on to build socialism.

Later the building of socialism was replaced by traditional values.

Fortunately, Ilka is not like that. *Those were dreadful times, be glad you didn't live in those days.* She is less prone than I expected to mythologizing the past, to nostalgia likewise.

19.

It has gone dark in the meantime, I'm not sure I remember where exactly I'm staying overnight, in which wooden cottage. All I do recall is that there was ice everywhere on the way here, but I won't see it now as there will be no lighting.

Iľka insists on coming with me, I am more worried about her, as she uses a walking stick. Right now we're going up the hill but later she'll have to go downhill on her own, I offer to walk her back to her house but she won't have any of it. The most I can do is stop her from going any further, and after a while she finally does stop and says goodbye.

I stand there watching her walk away until she disappears in the dark. I can hear her footsteps and the tap-tap of her walking stick for a while longer but now three female voices are approaching, three Roma women from the settlement. I get lost a few times, but after I find my bearings, I ring her.

She didn't trip.

She's expecting me tomorrow morning. We'll carry on.

20.

She shows me a newspaper clipping, a short article with her photo. It's from a regional newspaper, she received an award for promoting the local cultural heritage, she keeps it displayed above the micro-wave.

She also features in a book about individuals still practising traditional crafts in this region. There are very few embroiderers left: Iľka, then a lady from Pohorelá, but the folk costume there is

quite different, the bonnets are different and the religion is different too; then there's a lady in Vernár shown with richly embroidered or woven pillow cases and eiderdown covers: a trousseau, for which sometimes people had to sell a cow.

And there's a publication that mentions Iľka in her capacity as an actor, at an amateur theatre festival marking the centenary of the writer Jozef Gregor-Tajovský. Iľka was roughly as old then as I am now. The name of the festival organizer rings a bell, his son was Gizela's neighbour. *A fine figure of a man he was*, Iľka says.

And, finally, the book by her friend the psychologist.

Iľka's life is already on record.

The chapter about her is headed *All She Never Wanted.*

It wasn't so much her forced marriage, the hierarchical relations seem to have been more of a problem than the poverty, the cramped living conditions, the lack of privacy. She moved into the neighbouring farm, into a family with greater means and was treated accordingly.

Another expression I remember from the psychologist's book is *golden calf.* Iľka didn't like the fact that the villagers were worshipping a *golden calf.*

The book focuses on Iľka's younger years, where the psychologist identified the crux of her problem, a life she wasn't meant to live and a trauma she wasn't meant to experience, a mother-in-law who ruled over the household and Katarína, her eldest sister-in-law.

There is even a dramatic illustration showing Iľka standing above her mother-in-law's grave. It's like a scene from amateur dramatics. I no longer have to be scared of you, she's thinking, you can't harm me any more.

These are the things she had told me as well. How she had to sit at her loom at least for a short while after coming home from work. How she knew every single farm she could have married into, but didn't want to.

The book also deals with giving birth: the psychologist quotes Iľka's mother-in-law as saying that women today are lazy because they go into hospital to give birth.

After her mother-in-law gave birth, she wove two ells of cotton cloth by the next morning.

Of course it's the word *ells* that makes me prick up my ears.

It was around that time that women started giving birth in hospital, giving birth with the assistance of a doctor was a new development. Iľka's elder sister still gave birth at home.

I ask about ells and learn that her mother-in-law used to complain endlessly about women today, that is, women in the fifties, being lazy as well as immodest, exposing themselves as they did to the doctors during labour. On top of that, Iľka spent two weeks in hospital as there were complications with the birth.

She has buried herself in the past and doesn't let me get a word in. I'm not sure she's even aware of my presence.

She had to spend two weeks in bed. She could. Or rather, as her mother-in-law put it: *she could flaunt her cunt before the doctor*, Ilka says.

I'm taken aback, I find it hard to get used to it, this vulgar language doesn't suit Ilka even if she is only quoting her mother-in-law to give me the best possible idea of what she was like. Quoting her words has upset her, she has gone back in time and started to tremble.

But Ilka is not vulgar. I chide myself for asking her about the canvas cloth.

If I understood her right, the complications had to do with the placenta, only she used another word, whatever it was, it didn't come out and she had run a fever.

They called a doctor, who arrived drunk and operated on her in that state.

Meanwhile her mother-in-law told Ilka's husband, her arranged husband, that their child was born without fingers. Her husband came to the hospital drunk but wasn't allowed to see the baby. I believe Ilka tried to convince him that the baby was all right.

She often told me that a mother must always count her new-born baby's fingers. This came as a surprise to me, I didn't count mine's, perhaps it's another superstition. Either way the child was not with her but with the nurses, because of the complications, and her husband didn't get a chance to check until they came home two weeks later.

She is on the brink of tears, more so even than when she was talking about the Roma man at the hospital. This is something she hasn't fully processed even 60 years on: who knows, she might have been suffering postnatal depression, which wasn't recognized in those days. She spent the entire two weeks in hospital crying and then went back home, to the shop, to the microspace where women are not allowed to go to the cinema in case that makes them give birth to children who are hideous (she used the dialect word *bridké*), a world where you can't say no to anything you're offered, as that would prevent your children from ever marrying, where you are not given any oxytocin after giving birth. But what I actually asked her about was ells, ells of cotton cloth.

I wonder what kind of rules they have to observe a few houses down the road, in the settlement. How several generations manage in a single house. First it was the mother-in-law who did the cooking, then her eldest sister-in-law and, finally, Iľka herself. This was the sequence, invariably.

But eventually she did manage to buy a house, the one I'm sitting in now. It says in the psychologist's book that she bought it on unfavourable terms, unfavourable in the sense that the house belonged to an elderly man, a widower and an alcoholic, who sold it to them but continued to live there in a shed or some outbuilding behind the house. But at least Iľka got away from her mother-in-law, and an alcoholic in her courtyard was the lesser evil.

For years she used to wake up from the same nightmare.

She's at school and doesn't know anything, is unable to answer any of the teacher's questions.

At home she cries every night but during the day she has a laugh with the actors in the theatre, after the day's work of course, after her shift in the shop and another shift at home, an emancipated socialist woman in the Slovak countryside who had to fear the police if she sold more than a kilo of sugar per person, because someone might use it to distil liquor. Everyone was into distilling. But she was even more in fear of her mother-in-law than of the police and would always bring back from the shop as much sugar as she demanded.

My daughter came back from kindergarten with five fingers intact: thumb, pointer, middle, ring and pinky, there they all are, rinky-dinky!

21.

There is a gap between the houses across the road, two empty lots. This was where the settlement had been originally. In fact Iľka has lived among Roma all her life. *I have nothing against Gypsies*, she says, *they were decent people*, they all worked metal or built the Margecany–Červená Skala–Banská Bystrica railway line.

But the Roma today, I do have something against them.

I learn more about the portacabins: the settlement across the street had burnt down and this was the municipal authorities' response.

At the same time the authorities moved the settlement beyond the village limits. The only part of the story that is remembered is that the Roma went off to sell the bunk beds the next day. We don't know if anyone was hurt or died in the fire, or what it must have been like to be shunted off to another place, even if it wasn't far away. The fire must have started somehow but we don't know how, we don't know what it was like for the community to wake up with their houses ablaze and all their possessions reduced to ashes. Now there's grass growing there and the only thing we know is that the Roma didn't want their children falling off the bunk beds.

I asked if any of the local Roma had been hauled off to labour camps during the war. She doesn't know about that, here in Šumiac they used to get on fine, but she does remember her brother-in-law, who was in the resistance and was captured on his way home from the Vepor Mountains. He'd been on the road for three months and when he returned his own parents didn't recognize him.

There's a beggar at the door.

This sentence must have been repeated for decades in the family. The doctor warned them that he should take his time getting back to eating normally, so they used to bake him buns, like

the ones we warmed up in the microwave, without any jam or any other filling, just steamed leavened dough.

22.

I remember playing with money in the till, even though Grandma said it was dirty and not ours and she had to take or send it to the post office every day. She told me how she used to send my 12-year-old mother with the whole of the day's takings in her kiddie handbag all along Dolná Street to the central post office in Banská Bystrica's main square.

That's why I feel so much at home in these small village shops, the shops with Boženas and chimney stoves.

The word *manko*, shortfall, floats up from the depths of my memory, it was to do with a Roma woman with lots of children—in those days everyone still called them Gypsies. Gizela would sell her something on tick and then have to cover the shortfall out of her own money. I couldn't make head or tail of the story, to me *manko* sounded like *mamko*, the word for mother, but the message was clear: you can never trust Gypsies because they tell lies and they always will. The debt was eventually forgotten.

Gizela too hated her job with a vengeance and was looking forward to retirement and to no longer having to lug heavy things, put compresses on her swollen arms, stand behind the counter and be around people, as she spent quite enough time with them anyway.

A walk down Dolná Street would take us hours because she knew everyone in town and so we had to stop after every few steps and chat to someone and I would be left standing there for minutes on end, bored, before we'd take another step or two and had to stop again, all the way until we got to wherever we were headed—home, the shop, church, wherever. In those days, there were *Gypsies* living in the centre of town, in every courtyard and every building, some presumably even in the historic Hunchback's House where I would stand gazing up at the relief above the gate, showing a stork with a human face for its body, pecking it with its beak.

Gizela used to cry every day, as she never got over the fact that she couldn't continue her education, she went on crying even when she no longer had to work in the shop. She had left her home village at the age of 16, but even so, 10 years later a marriage was arranged for her, and for the rest of her life she claimed that she married out of spite. It always made me laugh, what a great reason to marry.

You really didn't love him, not even a little? No, not at all.

They had two children together, but for many years my grandfather had another woman from Dúbravica on the side. Their children grew up, had children of their own, and when Grandpa learnt of the other woman's death, he had a stroke, that I remember well. Gizela looked after him until the very end and before she herself died, she said it had robbed her of her last bit of strength: he was huge, bedridden and gradually losing touch with reality.

And then, just before the end, when he was practically on his death-bed, love suddenly blossomed for a short while. He showed her greater consideration and gratitude, and she offered him more tenderness: it felt good to be appreciated for her efforts and sacrifices at last. But then one day he called her by the other woman's name and that was that as far as love was concerned. Grandma continued to look after Grandpa until he died and joined his woman from Dúbravica, and after that Grandma had no strength left either and soon, she too was gone, and I will never know whom she had joined.

It's sheer coincidence that I've been coming to see Iľka, a coincidence that they had the same job in a co-op, that they were both married against their will is another coincidence, and their shared trauma in their childhood or youth is a coincidence too.

We carry on.

23.

I'm walking up the village passing small groups of Roma children who, being Roma, as a local man said yesterday, probably have no one but themselves to blame for it.

The children are going home from school, some eating crisps, others listening to loud music, Romani pop, the girls stop now and then by gaggles of boys hanging around at the side of the road. They're all Roma children, not a single gadjo among them.

I love you even if I don't see you, an older boy reads out to a smaller one from a piece of paper. It's Valentine's Day, of course, I nearly forgot, someone must have given this to him, the young Valentine is headed for the settlement, and I wonder if Iľka is sitting at her window, watching these little groups of kids.

I love you even if I don't see you.

A lovely Valentine's message, considering these kids see each other at school every day.

Iľka has actually never complained about her husband, which is quite remarkable as they weren't in love at the start of their relationship and she had to learn to live with a stranger. The only thing she complains about is that he didn't want her to go to rehearsals. But she found a way around that.

24.

I recall one of the first questions I asked her, to find out whether she retired straight after the revolution. Iľka asked *if I meant the time* that the Russian tanks arrived. No, that was 1968, I meant 1989, by which time she was over 50, but for her the reference point for that period was the birth of her grandson, the tenor. The Velvet Revolution brought about no changes in her life. She is about a year younger than Václav Havel but she didn't notice the revolution or, rather, it passed her by. With her working life over

and living in Šumiac, she had no way of registering that something fundamental had changed.

Before retiring, she worked as a cleaner at the transmitter on Kráľova Hoľa, at the radio communications building, and before that she had a job at the Strojsmalt plant in Pohorelská Maša, in the canteen. The factory used to support the entire region before going bankrupt 12 years ago. Before this final stretch Iľka had taken a year-long break, but still managed to clock up the 35 years that enabled her to take early retirement and claim her pension. Then another 30 years at home as auntie Iľka, a pensioner, finally well and truly old.

25.

I board the bus at Brezno station. Full of anticipation. The bus will fill up in the town square and then will start emptying as we stop in Beňuša, Bacúch, Polomka, Závadka, Heľpa, Pohorelá, Pohorelská Maša, Vaľkovňa, Šumiac and Telgárt.

I enjoy memorizing this sequence.

It's about fifty-fifty on the bus, with the majority of Roma at the back where I sit: four Roma women, two younger, two older, all well-groomed, indistinguishable from gadjo women. The younger ones are very pretty, the only problem is their teeth.

Nearly all the seats have been taken now and a fellow is approaching the Roma women, a broad drunken grin on his face, he would probably spread his arms wide if he didn't have to hold on to the handrails. Lecherously, as if about to lunge at them.

Now where should I sit, ladies? I'll just have to squeeze between you.

He manages not to miss the middle seat of the five, grabs hold of the knee of one of the Roma girls as if it were a handrail, without giving it a glance, as if it were an object that was there for his use. The moving bus hurls him onto an older woman on the far side, she jumps up, *worse than a Gypsy, just look at him, rolling about on these Gypsy women, who does he think he is, squeezing himself between them*, she shouts before sitting down next to a Roma in the row in front.

Addressing her informally, rudely, the drunk replies that *he will sit wherever he likes* and then goes on, *who does she think she is to be telling him where to sit*, the girls don't dare open their mouths, the Roma man keeps quiet, as does a man sitting behind me, everyone pretends not to notice. I keep my mouth shut, too, observing it all and quite shocked, although that's no excuse, I exchange smiles with the woman who shouted at him earlier, and when it's all over, she goes on talking, but only to the Roma next to her, in Romani. The only thing I make out is 5 euros, and then 20 euros.

A minor everyday incident. But I missed the chance to take a look at the settlement on a slope behind Brezno that looks like

the continuation of the town square, a street resembling a South American favela and just as photogenic.

It's got warmer.

I see Roma children in T-shirts by the roadside. The snow has melted, the peaks of the Low Tatras still glisten white.

The two older Roma women and the drunk get off in Polomka or perhaps Pohorelá, the girls get off at my stop in Šumiac, so they are likely to be from the local settlement and live not far from Iľka. I wonder what kind of mirror they use to do their immaculate make up. We leave the smell behind in the bus, the first indication of the dividing line between White people and the Roma: heating with firewood and life without hot water leave their mark.

A stall has been set up at the bus stop, I don't know if the vendors are Ukrainian but they do sell lace and trinkets and fabrics, just like Iľka said. The village seems familiar now, the chapel, the school, the municipal office, the church, the cemetery, the monument to the Slovak National Uprising, the community centre, the organic grocer's, the hairdresser's, the supermarket in the centre with a restaurant on the upper floor, the Roma children, with a sprinkling of White ones among those over 10.

The shop with the wood-fired stove is full of Roma, and a blonde lady can't resist a sarcastic remark about the things a Roma couple are buying. The roads are dry, there are snowdrops in the gardens, and coltsfoot by the stream. I feel like taking a walk.

26.

Last Saturday members of the folk ensemble from Vernár came to see Iľka and commissioned ten pairs of zapiastky, wrist warmers. This will keep her busy for two months. She has completed two bonnets, repaired one baršon, been to Brezno to buy woollen yarns.

She has stretched the warp over a tapered log. By following a pattern she weaves yarns of many colours around the log, creating a texture that is firm: the wrist warmers are meant to protect men's wrists and they used to be made by them. Originally they were black and white, made from the fleece of black and white sheep, but these days they are multicoloured: I wonder how far the bonnets have changed. They must have looked quite different at the beginning of last century—the Šumiac folk costume might have been quite different even 20 years before Iľka was born.

I admit I haven't made any progress with the bonnet at home. I couldn't remember even the easiest stitch.

She shows me the stitch again and off we go, she does her weaving, I do my stitching, as it should be, I manage a few rows, well done, she says, I'm ready to move on to the real thing: I will be able to deal with the back of the bonnet and then tackle the chain, as she calls the embroidered band along the hem.

Iľka launches into a detailed explanation of how she lost nearly all the credit on her mobile. She's had many calls today and it turns out that she has quite a few visitors, so she is definitely not

lonely: people flock to her even if she herself doesn't venture any further than Brezno, and even there only if she can get a lift, in order to see a doctor, stock up on materials and ask her phone provider where her credit is gone.

There are moments when I feel like I'm at Gizela's. Pensioners' problems always catch up with them at home.

Brezno is 42 kilometres away, an hour's drive, too far considering you have to catch the first bus in order to get to the doctor's in time for an appointment, only to be told that you won't be seen that day and will have to go through the same thing the following day.

Then there's Poprad, a larger town, as far away as Brezno, but even more complicated to reach. Besides, Poprad belongs to another administrative district, outside her catchment area for government offices and doctors, so she rarely goes there.

There is also Revúca, but the road leading there is full of hairpin bends, the locals have dubbed one of the bends *vracačka*, which sounds like *vracať*, to puke. I sympathize, as I usually get dizzy and nauseous on that drive, but in fact the nickname derives from another meaning of the verb *vracať*, to return, suggesting that you end up in the place you started.

Everything here depends on connections: you can't get anywhere without help from others, not even to the hospital. The older, poorer and less mobile a Šumiac resident is, the more connections she needs, though this is precisely what Iľka is not short of, with a dense and active network stretching all the way to the Roosevelt Hospital in Banská Bystrica, unlike those who live on the wrong side of the divide.

Gizela too had countless acquaintances who helped her get things sorted, as she seemed to know everyone in town and beyond. If it had been up to her to teach me how to make a bonnet, we would never have begun, because she wouldn't have trusted me to manage.

I feel that here I'm just a few steps from the end of a cul-de-sac, in a corner, in this house at the edge of the village bordering on the Roma settlement, after which there come the woods, and then another Roma settlement and a village where the Roma are in the majority.

It's where the Upper Hron valley and the counties of Liptov, Gemer and Spiš meet.

27.

I examine Iľka's own bonnet, not the one she wears at home every day. That one has no embroidery, it is just shaped like a bonnet, with a kontík at the top and a ritka, the bit at the back that is stiffened with extra linen, simple lace on coloured fabric.

Her home bonnet, like her skirt, forms a part of the folk costume, and she wears it with a cotton T-shirt, often with a picture or text printed on it, or a jumper.

The bonnet I'm looking at now is the one she wears to church and it's slightly different from the others. Among florals in bright warm colours there are tiny blue flowers. If it were up to her, the

whole bonnet would be blue, certainly blue would predominate. I can see now that Iľka has smuggled in the blue flowers, inserted a fraction of her own identity into the uniform.

I'm getting confused again, unable to tell the Telgárt roses from the Šumiac ones, and besides, the rose in this particular bonnet looks more like a tulip. Iľka has grown more open-minded: anything goes.

She fetches a coffee tin with a pattern of yellow and orange tulips she has kept as a possible model.

She keeps it in the sideboard and uses it for storing split peas.

I make another attempt to internalize the rules about the limits of what is allowed. I've seen quite a few bonnets by now, and if I picked out the quirkiest elements from each and used them all, I could create something entirely new. In any case, the bonnets made today are quite different from those of half a century ago: they have become much more ornate, colourful and boast bigger pompoms.

Only brides were allowed to wear ribbons on their bonnets and only for the year following their wedding. But of course everyone knew everything about everyone in the village in any case.

Nevertheless, questions do crop up: for instance, what do you wear to church when some time has passed since the death of a distant relative—what colour should the baršon be, must it be black? But what if a close relative of the bride dies a few months after the wedding?

It's a public statement, the expression of a shared approach to certain relationships or situations within families, and a solution to such problems was provided by headscarves in brown and magenta, additional shades that adjust to various events in life: particular situations dictate how people dress.

That makes the pews in church easy to read during mass.

This was before I had ever laid eyes on a black bonnet, but it was around this time that Iľka mentioned a young woman who had recently died in the village. She was around 30 and the whole village went to her funeral, but Iľka wouldn't go, she could no longer stand for so long.

28.

Whenever I tell any of the locals where in Šumiac I'm staying, they invariably ask if that's the boarding house that used to be a family home, even though it's the only boarding house in the village.

There used to be a well in front of the house where Iľka grew up.

She fell silent, as if this statement explained everything.

For someone else this could well have been the answer to the question of how her marriage had come about, how she ended up

in a household where halušky, gnocchi, were made differently from the way her mother had made them at home, just three houses down the road. The priest had alerted her to this in the course of their premarital advice session, and true enough, it turned out that Iľka's mother-in-law used to cut halušky with a knife whereas Iľka used a spoon. Or the other way around. Either way, Iľka had to change her habits: this was a matter of fundamental importance.

And this was not a metaphor, like 'stirring up a hornet's nest'.

Had I been as familiar with the local context as Iľka, I would immediately have realized that the well was where every important matter was discussed, as this was where all the women met and arrangements were made or unmade.

An unmarried girl would be there for all to see, *available*, *marriageable*, and so the wedding was planned, she and the groom would have known each other since childhood, he used to go out with her sister before Iľka, who, in turn, had dated another young man before him, 10 years older, someone not from their village, not even from their region, whom she had met on a May Day parade.

But she ended up marrying the neighbour's son, a lad from a nearby farm. By then it was clear that Iľka wouldn't continue her studies. She got a job at the shop, gave birth to her first child in 1959, and another son followed 10 years later, because you have to honour the Fourth Commandment even when you grow older,

it comes before 'Thou shalt not kill', just like 'Thou shalt not commit adultery' comes before 'Thou shalt not steal': the Commandments are displayed on the wall and on the frame sits Igor, one of God's creatures that Iľka is looking after.

An unmarried woman who has a child is known as prespanka, or knocked up, regardless of how it happened. The sooner there's a bonnet on her head, the smaller the chance that the girl will be treated as a second-class woman. This was the case until the sixties, perhaps even the seventies.

Iľka's marriage lasted 40 years, 40 years of living with a husband is not an eternity, one can survive provided not too much domestic violence is involved or at least if it's not excessive. Iľka's husband wasn't into that, he was a peaceable fellow.

When it came to sex, he respected her.

Iľka emphasizes this, having brought up this subject herself.

In the end, something akin to love grew between them. It's always hard at the outset, and later you live for your children. She thinks for a moment if there's a better way of putting it, but she can't. You have to bear it, just grin and bear it. If there was one thing she couldn't bear, it was her mother-in-law in the early years, and the physically demanding job in the shop, having to lift and unpack heavy sacks. If her hand slipped and she happened to pour some flour into the salt, she'd have to sell the flour salty, the same amount to everyone, everything was rationed.

Whenever something she doesn't know comes up in our conversation, she apologizes and says she had missed out on her education.

Her husband didn't cause her trauma or give her nightmares: they learnt to live with each other. He would help her with the loom, he knew how to deal with the ells of cloth, and she appreciated that. He was a driver with the State Forestry Agency, transporting forestry workers and timber, and after coming home in the evenings, he'd have a drink and fall asleep. He was the jealous kind, though, that's for sure.

She went to rehearsals, and even toured with the theatre, which was highly unusual, as village women are not into such things. They don't become actors, they don't memorize lines that require them to speak to men on stage, men who are not their husbands, they don't strut around in front of an audience of drunks in the resort at Predná Hora. For the second time she tells me about an occasion when a section of the set fell on top of her when they did a show there.

After her husband died, she had to remember to keep the front door locked, to get used to the fire going out in the stove, change her daily routine, apply for her widow's pension, have central heating put in.

She had to keep on living. Keeping the double bed.

29.

The closer I get to the end of the village, the filthier it gets: plastic bottles, cigarette packets, bits of clothing and cars, mostly dumped into the stream right in front of the Roma settlement. I say hello to a man with a small shovel scooping piles of earth into a bucket.

I walk into the settlement with the idea of taking the unpaved road towards Telgárt. The settlement merges imperceptibly into the village—as with the back seats on the buses, only an imaginary line divides the two parts, a line that the Whites rarely cross, so my presence raises questions, mainly from the children. Hello, who're you looking for, hello, who're you visiting?

Hello, nobody in particular, I'm just taking a walk.

Got a camera, auntie?

I must disappoint them. All I have is my head, I'll have to commit them to memory. They can tell that I'm not a local: so where are you from, auntie?

The settlement forms part of the village, its back end, except that White people don't come this far, even though the houses don't differ much from those on the other side of the line: some have walls of cement, others are roughcast, some are even insulated, the main difference being that this is an open space, there are no fences, no back or front gardens, just mud. Social workers have a saying: you can tell a village mayor by the Roma settlement he

keeps. At the far end there's a well-kept pink house with astroturf around its entrance, the stream running along this part of road is chock-full of rubbish, which can be a problem as the blocked streams tend to overflow in the spring. Presumably waste disposal is dealt with in the same way as the supply of water—if you don't pay, you get neither. But what do I know?

This is the main street. It used to be paved once, it's buzzing with life, the place is teeming with people, children chasing each other, women sitting out in front of their houses, although there's a further layer that forms a kind of parallel street to the left, at the foot of the hill: a few dwellings just knocked together and a couple of wooden outhouses. They lend the settlement the appearance of being scattered around the landscape and stretching up the hill, a pleasing effect when viewed from afar, a progression. How did they survive here last winter, when it was 30 below?

Later I learn that the same dividing line exists between the back end of the settlement and the main street as between the village and its Roma settlement.

The back end is the slum.

The back end belongs to the lower caste: the difference can be clearly seen from the hill above the village, and so can the relative proportions: this part is very small, you'd never imagine that a third of the population of Šumiac lives here. The village may be big, but many of the houses and cottages are empty or abandoned; while some have been fixed up, others are dilapidated. The locals

suspect that the properties, both new and renovated, will keep going down in value at the same pace as the White children are disappearing from the school, with hardly any left in the kindergarten today. Unless something changes. Ten years, give or take.

I climb up the hill. Kráľova Hoľa is still carpeted in snow. This is for me the most beautiful spot in Šumiac so far, with the best view, though the amount of rubbish is constantly increasing, this being basically the local settlement's rubbish dump. At the top of the hill there is a cross and slightly less rubbish, and as I descend the far side of the hill it's cleaner again, these are the presentable foothills of Kráľova Hoľa, breathtaking, as spring is coming, the first days of early spring, though winter will take its time to retreat. I climb down to the valley, jumping over patches of snow, how far should I go, how much further to Telgárt? I expect I'll have to pass through another settlement on the way.

I'm not sure whose antennae are more aquiver, mine or the boys'.

They have two dogs, and one of the boys, the younger one, has an axe resting on his shoulder.

When I notice that, I turn around and join them, I'd rather not have them walking behind me.

Somehow, we manage to communicate, the boy with the axe speaks only Romani, the other knows some Slovak and acts as interpreter, for me it's more guesswork than understanding, the younger one lights a cigarette, as if he's given up on what goes on in a foreign language. They tell me they're also headed home, their

dogs have caught a whiff of something, I'd better be careful, there's someone lurking in the forest. The younger one is 15, the other a year older. I ask if there's something to be scared of in the forest: he says something about a cottage and that someone turns up at night, at around two or three in the morning, knocking on everyone's door in the settlement. It's not clear how the two things are connected but this was his answer to my question as to whether there was something to be scared of around here. I ask if they have mentioned this to the mayor. The mayor is an idiot, he says, laughing at me, forget about the mayor. We walk on in silence for a while, the younger one with the axe is chain-smoking, the other takes out his mobile and starts listening to music, Italian pop. They have spotted deer in the forest, but deer are OK.

Deer are OK, they won't harm you.

They're chatting away, smiling, suddenly they seem childlike, the axe more like a toy and the Italian singer is crooning about something she needs, I wonder what that might be. The snow-covered Kráľova Hoľa rises above us, looming above us, if you like, towering above the fly-tipped sofas, the meadows, and the piles of rubbish lining the road, its peak is at an angle, it's the quintessence of the romantic, this, the three of us and two little pooches, the cigarette, the axe, the smartphone, Italian pop, sun, sole, pizza and halušky, every village should have them! We're almost at the settlement. There's a fellow coming opposite, also carrying an axe, followed by four more young men.

Now come for a walk with us.

They're laughing, they are around 20, smartphones, cigarettes and axes, they carry them like valaškas, shepherds' hatchets.

My two companions peel off one after the other and head for the most ramshackle hovels. Young slum kids, they might get a dressing down from their mums for coming home empty-handed, without any wood.

I walk to the end of the settlement, answering predictable questions, on the other side of the dividing line I come across the man from the meadow again. He has a squint and is gap-toothed, but this time he starts talking to me. He asks whether I'm scared of bears, and I tell him the dogs in the settlement have caught the scent of something.

He spits out two bear jokes, I forget both, neither featured a hare. This man is not rough in the way I expect mountain dwellers to be—though actually, why do I expect that of them?—but what I find is the same kind of kindliness and vulnerability as in Iľka, the same shyness, while his sense of humour is exactly the same. I'd like to meet more people from this village which, as this nice fellow claims, is *being overrun by these Gypsies*, his house is now very close to the settlement, and he was taking some soil to his wife for their garden.

Iľka calls my walk 'gallivanting around the village'. I'm sure she never goes walking in that direction; as far as she's concerned, the only way you might end up in the settlement is if you got lost. To go wandering around the village meant not getting any work done. Nor did any work get done when she visited her mother: no wonder she always sent her home.

Spring has brought rubbish in its wake, and suddenly I also notice more pregnant young girls. This is not a myth: they really are very young, 15 or so, just like the boys I met on my walk, some are even younger. This is the kind of thing that rankles with Iľka and she goes on about social benefits, the dole, them being workshy. But why should children have to work?

They make babies to get the money, she says. I think it's unlikely that these children, who barely speak Slovak and when they do, they write loving Valentines to each other at school, would be thinking about money in such a hard, calculating way.

I heard a story about a young Roma woman—I heard it because she was a singer and I'd seen her perform. She used to appear on stage with a man, both of them in wheelchairs, and she was blind and not particularly attractive, but their singing was beautiful and poignant. Even so, their disabilities turned them into something of a circus attraction: they seemed tiny and utterly lost on the enormous stage as hundreds of people listened to them sing. And then I learnt that the singer got pregnant, it just happened, someone in her settlement did it to her—I imagine it wasn't entirely consensual, possibly not at all. Can you imagine anyone being more vulnerable?

Only men drive cars in the settlement, while it is mostly women I see doing public works, only once did I see a man. This time they were clearing grit from the roads, and back in January, too, there were only Roma women shovelling snow outside the municipal office.

30.

A younger friend, a neighbour of Iľka's, has dropped in, a former colleague from the shop. This must have been towards the end, when she got a job in a supermarket, where the burnout hit her with full force.

Once again everything is different from what I imagined.

It's the smaller shops that she can still just about bear and the supermarkets where it all began: she often felt unwell all of a sudden and had to be sent to work in the warehouse.

These days she can't go to a supermarket at all: the minute she walks into a larger store she is gripped by anxiety and panic, she gets palpitations and can't take it. She can shop only in places where things are sold over the counter, only the nearest shop in fact, she can't make it any further.

Her younger friend doesn't look that much younger, although she's nearly 20 years Iľka's junior, solidly built, short hair, half an inch of grey roots showing. She has come to pick up a mustard-coloured baršon. Iľka has replaced the torn fringe and involved her in the creative process. The friend has a sewing machine, she is a good seamstress, and Iľka has received an order for two boys' shirts for a folk costume which the neighbour will make and Iľka will embroider. She cultivates links with others. It is something she does deliberately, she tells me later.

Her neighbour explains that it's just what she needs, as it helps her to relax. She is very keen to show exactly how it relaxes her and for a moment I expect her to give a practical demonstration: *It just relaxes me, you see, I don't know how to put it, I just get so, so relaxed* she says, breathing in a relaxed way as words desert her. A state of relaxation has arrived.

You don't need to explain it to me, I know all about therapy, I am thinking, but I let her continue.

I find it moving that she's trying so hard to make me understand.

Ilka shows her the embroidery I have done and the neighbour showers me with compliments. I'm ready for the real thing, I'm up to tackling the back of the bonnet.

31.

Once we are alone again, Ilka tells me how they modernized their wooden cottage after buying it from the alcoholic.

That was the beginning of a new chapter.

They got a non-repayable loan from the State Forestry Agency. Now I understand where all these houses come from, all those brown cubes coated in lime plaster that have come to define

Slovakia's villages. After the collective farm was founded in 1975, they no longer had to hand in quotas.

I mention the date deliberately. I was born in the late seventies and Iľka's younger son was born 10 years earlier, except that everything lagged 20 years behind in these parts, apart from the non-repayable loans. After all those years when everything had to be handed in to the state, it was hard to believe that working for a state enterprise for a few years would be enough to be given money for a house.

Iľka's husband didn't trust loans, he was scared of them, so she had to arrange the non-repayable loan herself, with the help of his colleagues—how likely was it that he would change jobs?

And she ended up being in charge of the refurbishment as well, with a little help from her father and the entire family.

The money could be spent only on limited quantities of building materials, the bricks had to be sourced from a specific brickworks, they were the only kind available. And it was the same with everything else, people would build their houses out of whatever material they were able to lay their hands on. The whole family would be roped in, the cement mixers travelling from yard to yard.

Are you widowed or a prespanka?

This was the question she kept hearing from the men, *tie chlopi*, as she calls them in dialect, who delivered the building materials. They asked because they'd never set eyes on her husband, until one day, when they arrived at four in the morning. Finally

there was proof of his existence, as he had to get up and help them unload.

Collecting the bricks involved another early start, having to borrow a car and arrive at the brickworks in Revúca by five or six in the morning and load up the bricks straight from the kiln. Ilka was on the verge of fainting, on the return journey they had to sit on the still-hot bricks and then spent the rest of the day running to the toilet. Building the house as fast as possible, by Christmas, moving in while it was still damp, falling ill and taking a long time to recover from some ailment or other. Getting used to living with others, going to work and then burning out, taking early retirement, marrying off one son, then the other, not meddling in their choice of brides, burying her husband, embroidering, weaving, knitting and crocheting.

And, meanwhile, reading—never stopping her search for the book entitled *Between the Waters*.

She has a copy of Andrej Sládkovič's *Marína* with a facsimile of the poet's handwriting. She used to read anything she could get hold of, she'd order books from journals and through the lottery: every ticket that failed to win could be exchanged for a book worth up to 10 crowns, so that was what she used to do—she didn't go to the library much. When she was younger, her teacher had lent her a few books but later she stopped reading and started making folk costumes, ending up as a character in her psychologist's book. I think she was quite chuffed by that.

32.

It's just as she said on the phone, her daughter-in-law is at her house when I arrive. There are lots of wrist warmers to be made, all identical, the work was starting to become monotonous, she has to stick to the sequence of colours specified by the customer, and the job needs to be completed as soon as possible.

How come her daughter-in-law has only now started to learn the craft? The three of us sit at the table covered with a floral plastic tablecloth. Light from the narrow courtyard is filtering through the window, in winter it was full of snow that had to be shovelled away, otherwise cars couldn't pass. Fortunately, now it's only raining, although it can snow here as late as May.

I continue stitching, this time I've made more progress at home, I'm still working on the back of the bonnet, the zadník, and when I've finished the band of plain stitching we'll move on to the florals in the middle: some bonnets have a geometric pattern but flowers will be easier to do.

Iľka's daughter-in-law encourages me to go for bolder colours so I add a yellow stripe. *Now that's better, see how much better it looks now.*

I must come across as timid. Iľka serves buns and tea, it's time for a bite, clearing the table and showing how much progress I've made.

This situation feels uncomfortably intimate, I never experienced anything of this kind growing up, I never spent so long with my mother or Gizela, my mother was either away or about to leave.

I observe, I stitch. Good job I have my embroidery and can watch and listen without having to talk. I'm not cut out for this kind of banter and quick-fire repartee. Participation in some joint activity eases the tension, the work requires concentration, otherwise you mess it up.

Ilka's daughter-in-law has to undo a whole row: she was talking about her mother's death and used the wrong colour, she has to start all over again.

Ilka is happy, as far as she's concerned everything is as it should be. This is how we are meant to be, sitting here together, chatting and working, sewing, knitting and unpicking, helping one another, we are meant to feel good in each other's company, sharing our problems. This has always worked for her, it helps. As for me, however, all I can do is listen.

I don't know who brought up the Roma. Every conversation ends up with the Roma, the *Gypsies*, who pass her house on their way to the village, because that's what they are called here, *Gypsies*. Ilka claims again that *Gypsies in the old days* were worthy of respect, unlike the present-day Roma. Roma in cars, Roma with smartphones.

They tell stories, the local lore, like the one about a Roma woman spotted breastfeeding on the road. Her baby was already full and tried to pull away from her breast but she said: *Eat up, or I'll let this gentleman have some*, pointing to a man who happened to be passing by.

Then there's the one about a doctor who used to visit the Roma in their homes, *she had to visit the Gypsies, too*, adds Iľka's daughter-in-law, *and she saw this Gypsy woman making pancakes*, and she said to the doctor, *help yourself, I've made them with mine*, and the daughter-in-law clutches at her breasts like the Roma woman allegedly did.

The final story involves the local bus and *an old Gypsy woman* who was toothless and eating a bar of chocolate with hazelnuts. There used to be only one bus driver serving Šumiac in those days and there were fewer Roma, so everyone knew everyone else. As she got off the bus, the woman offered the driver some of the hazelnuts from her palm.

Here, have some hazelnuts, mister.

The dividing lines are elsewhere, they are everywhere, and there are linguistic ones too. Romani is incomprehensible but even the way people speak in Pohorelá, the village that's just over the mountain or rather, across the meadows, is so different that their dialect is impossible for us to understand. People still speak in dialect in these parts.

Iľka's daughter-in-law tells us about the time she got a job in a factory in Pohorelská Maša. She would have breakfast with the women from the neighbouring village, but at first, she could barely understand them. They said to her, *a ty čuš*, and you shut your trap, so she kept quiet. After a while someone else said *a ty čuš*, so

she kept mum until she realized that they were asking her a question: *A ty čo?* How about you? It must have been Pohorelá's version of the Polish *cóż*, not a particularly welcoming thing to say but not quite as bad as shut up.

The folk in Pohorelá are southernmost Gorals, related to the Polish Górale, while those in Šumiac are the westernmost Ruthenians. Even after the war mixed marriages between villages were still quite rare, so the language is different in every village and then of course there's Romani on top of it all.

Iľka complains that her belly hurts from laughing, she can't stitch or knit the wrist warmers. Her daughter-in-law is a great storyteller, a natural, this is her way of getting a handle on the world, she can even turn death into a good story.

But the yarns give her away, the colours don't match.

33.

The phone keeps ringing, a decision has to be made, are you coming to our place or are we going to yours. Iľka is used to this, I'm not.

We go to their place. Iľka hands me a chocolate bar, without hazelnuts, for me to give our hosts, she knows I didn't expect to go visiting anyone, although I do happen to have something.

I'm on the move, always headed for the same place, which is slowly changing along with me, permanently in motion, going round and round in circles, Bratislava, Šumiac, sometimes via Košice.

These neighbours live on the far side of the stream, where the Roma settlement used to be and where a few Roma still live. The three of us squeeze under one umbrella, the daughter-in-law's story on the journey is about a wardrobe, and how, before their houses burnt down, the *Gypsies* kept going into this wardrobe that stood by the stream.

Kasňa, she called it. Later it turned out it was their toilet.

I wonder if the word *kasten*, for wardrobe, came with the Germans, along with iron and steel mills and blast furnaces, kasten replacing chests and, exceptionally, even outhouses.

The table is laid. I am introduced to two generations at once, a handsome woman in her fifties, a little older than Iľka's daughter-in-law. Her mother is also here; she lives in a house above Iľka's.

And then there's her father. A thickset, dark, shaggy-haired fellow, with a thick black moustache, from a distance I might take him for someone from the settlement, but in fact he may be one of those Romanians who stayed in these parts during the war, though on second thoughts, no, he looks too young.

Perhaps he is descended from the Romanians, or rather, the Aromanians, from the time of the Wallachian colonization, who gave us terms to do with sheep farming, such as *valach*, *bryndza*, *salaš*, *fujara* and *bača* and later assimilated, like the Ruthenians. They came with their own folklore and introduced the locals to grazing sheep in the mountains instead of on the plains, because

at one time sheep did in fact used to graze high up on Kráľova Hoľa, as Iľka once told me. However, this practice ended when the communists turned this area into a national park, since when the mountain has lost 3 centimetres in height, as it has dried out, and sheep no longer graze on the grass and the water just flows down over the flattened clumps of grass that has lain under the blanket of snow for half a year, flowing down without anything to retain it, not even the small pools that used to form in the imprint of the creatures' hooves.

No one knows where the Aromanians came from: there are a number of theories. In Serbia and Macedonia they are known as the Cincari, as they are regarded as descendants of the Fifth Roman Legion, and both the Greek Wallachians and the Aromanians use *haristo* to say thank you, which is almost the same as the Greek word. They are sometimes called *Kutzovlach*, Little Wallachians, as opposed to the Romanians, the big ones: *küçük* meaning small in Turkish, a word close to the Hungarian for small, *kicsi*.

The neighbour comes into the kitchen, looks at me and says, *not bad looking.*

He says it in Slovak, instead of a greeting, hoarsely, slowly, provocatively, almost in a sing-song.

The fathers of our hosts hadn't been on speaking terms since they were boys and the son of one married the daughter of the other, something that would have been out of the question just a generation earlier: a Romeo and Juliet with a happy ending.

There is a sexual innuendo underlying the moustachioed Romeo's every word. His Juliet tells him to stop it and get out of her kitchen. How dare he talk like that, a tetkoš, a married man, a Šumiac term derived from *tetka*, auntie.

I'm beginning to suspect that I am the main reason we are here. I answer the standard questions, such as where do I live and what do I do, then withdraw, like a child hiding behind her grandmother's skirts, except it's not Iľka but Gizela who keeps me on a tight leash, to make sure I don't talk too much or ask stupid questions and show off, that I behave myself. So I'm on my best behaviour, not bad looking to some, I may even blush a little while the tetkoš Romeo is in the room. I keep quiet even after he's left but then help myself to a piece of cake.

But here we have to live with them.

Here we go again: in the village there is a stray dog that barks at the Roma, it may even have bitten one, but it left Iľka's daughter-in-law alone, a dog is well aware who has ill-treated it and who feeds it.

The Roma take a taxi to do their shopping in Poprad. We try to work out how much it must cost on the basis of the fare to Banská Bystrica: Poprad is closer but it's in a different administrative region, buses are few and far between and you have to change in Telgárt. There aren't many cars in the settlement, but the locals claim that *everyone in the settlement owns a car*, they need one to bring the shopping home since the walk from the bus stop alone takes a good few minutes, the Šumiac bus doesn't go near the settlement.

Perhaps they pool their funds to take the taxi, but I keep that thought to myself and don't ask any questions, I'm on my best behaviour.

This is one of the local anecdotes: the *Gypsies* on social benefit do their shopping by taxi. The *Gypsies* pick and choose from the hand-me-downs, the *Gypsies* on social benefit won't wear just anything. Ilka's daughter-in-law overheard two Roma girls talking outside the shop:

First child bennie, then, social bennie.

She claims they have it all planned out from an early age. I think it's more likely that the girl got pregnant and was simply spelling out the life ahead of her.

We will never know what she really meant, and I have nothing to support my claim, and besides, I don't live here with them, I just overhear something from time to time. *I love you even when I don't see you.*

And yet, it's here in this house that I revise my earlier idea of where the dividing line between the settlement and the village runs. This Juliet actually talks to the Roma children, she helps to bring them up long-distance, she knows the older generation by name and has a rough idea of who is related to whom. No more than 15 families still live here but the generation thing probably works differently with the Roma, since they give birth earlier and die sooner, making it hard to keep track.

Someone mentions that there are several disabled people in the settlement, and I'm reminded of a girl I saw as I walked through the village on my last visit. She had a speech defect and made only inarticulate noises, the boys laughed at her and she seemed to be spluttering with rage.

I also recall seeing a couple of older boys holding hands and thinking that such an early and very public coming out was unlikely in Šumiac or in the local settlement. Now I realize that one of the boys is blind and is accompanied by his brother wherever he goes.

I love you even if I don't see you.

The Valentine's wasn't addressed to the boy. He intended it for someone else.

34.

All the disabled people in the settlement come from the same family.

They're Róza's children.

Róza is no longer with us. She had seven children, most of them not right in the head. There was Slávo, Šaňo and Gizela, I

forget the names of the rest. Either Šaňo or Slávo were nicknamed Dummy, but both of them were dummies. In fact, nearly all the kids were, one was allegedly a flasher, *he liked to expose himself,* Iľka says indignantly.

All the Roma have official names, but here in the settlement they have different, parallel identities, not necessarily nicknames. Here someone called Štefan Pokoš is never addressed as Štefan, Števo or Pišta, the standard diminutives of this first name.

Coming back to Róza: every one of her children had many children of their own, and their children, in turn, had lots of children too, and it is they who are the settlement's disabled, even though Róza was a person of standing in the village. When Iľka's daughter-in-law got married and came to live in Šumiac as a young woman, she asked Róza *What d'ya want?* using the informal *you.* This caused quite a stir and had to switch to the formal *you* whenever she spoke to Róza, just as she did when addressing every other adult.

35.

There was a storm in the evening and one of the collective farm's cows dropped dead.

Iľka's daughter-in-law returned from the evening milking soaked to the skin. A cold mountain shower. Easter's long past,

but a heavy fall of snow is not out of the question, yet a couple of kilometres further south the strawberries are slowly ripening.

When is it warm in Šumiac? In December—if the stove's going full blast. When is it summer in Šumiac? Last year it was on a Wednesday. Iľka's daughter-in-law could be my older sister, the way my mother was, as a matter of fact. All three of us are sitting by the window as we were yesterday.

The distinctive feature of artisanal skill: an activity is improved by constant repetition.

Those thin stripes on Šumiac skirts, how did they come about?

They seem almost town-like in their virtually unlimited combinations of colour; the explanation must lie elsewhere. The stripes are of varying width, often in darker hues and they run horizontally across the entire width of the skirt. Four metres of fabric are needed for a single densely pleated skirt, *riabkaná*, as they call it in Šumiac.

It's pyjama fabric.

The striped cotton poplin with a silky matte finish, the sort that men's pyjamas used to be made of. Well, well. A skirt made of pyjama fabric, I like that.

Iľka shows me another skirt, also with stripes, but made of a different material, something synthetic, both the fabric and the pattern are from the sixties or the seventies: this is what the first

minidresses were made of. In this part of the world, this kind of fabric forms part of the standard folk costume, worn with a black embroidered apron on top.

When did pyjamas reach Šumiac, when did people start wearing underwear? Personal hygiene was practically non-existent before the war, even in photographs from as late as the sixties older folk still have the same toothless, sunken cheeks, while skirts made of pyjama fabric have become an integral part of the traditional folk costume.

Now they have to send the skirts to Heľpa for pleating, but Iľka shows me how it used to be done. It was extremely time-consuming: the entire 4 metres of fabric had to be dampened and then ironed centimetre by centimetre, maybe even half a centimetre by half a centimetre.

Four hundred times. By the final fifty I might have managed to get the pleats straight.

36.

There is a fortune-teller in the village. Iľka and her daughter-in-law bring up the story of a woman who went to have her fortune told and then took the fortune-teller to court though they don't know what the outcome was. The family was even featured on a reality show, bringing shame on the entire village, and today local folk wouldn't be seen dead going to the fortune-teller and anyone

who uses her services does so on the sly. Apart for one exception: people say that Ján Slota himself had been here once to have his fortune told.

Slota, then still chairman of the Slovak National Party, was flown in specially.

Getting on a chopper and flying to Kráľova Hoľa to see the fortune-teller, that has since become part of folklore, just like his call for tanks to level Budapest.

Such things wouldn't be possible nowadays, when *everything is on the internet straight away*. A mayor once got drunk legless and his daughter had to take him home in a wheelbarrow: these days it would be all over the internet, but back then no one knew about anything, it was business as usual.

And every July *sovereignty* is celebrated on Úboč hill just outside Šumiac, the annual bonfire marking the anniversary of the declaration of sovereignty of the Slovak Republic which preceded the breakup of Czechoslovakia. It is accompanied by various events—nationalist fervour whipped up and organized by Slovakia's oldest cultural organization, Matica slovenská. In reference to the festivities in Šumiac, the chairman of Matica has declared that *the most selfless patriots live in the Slovak countryside* and their patriotism is manifested above all by the performances of folk ensembles, adding that the local choir, the Ensemble Šumiačan, came first in an international choir competition held in Russia.

We're now talking about life here today.

The male choir, the chlopi, were proposed for the UNESCO list of cultural heritage as being specific to the region: the polyphonic singing of the Upper Hron valley, guttural male voices that carry far and wide.

I try to shrug off the fact that this is where the members of Matica gather for their annual blowout, the Russophiles who embrace Pan-Slavism and glorify Tiso, the Nazi-allied president of wartime Slovakia.

In this village known for its anti-Nazi resistance.

I wonder if there are among them members of the families whose grandfather, like Iľka's brother-in-law, returned barely recognizable from the concentration camps, and had to be put on a diet of plain buns. There were another 15 men like him in Šumiac, but even more never made it back or spent the war in fear that the Nazis would burn down the whole village, as happened in Telgárt, later renamed Švermovo by the communists, after the resistance fighter Jan Šverma.

But what if the choir prefers to perform in Russia? What if these westernmost Ruthenians admire the Alexandrov Ensemble? It so happens that the ensemble is scheduled to appear in Brezno and the people of Šumiac are planning to go. Iľka's daughter-in-law and her husband have already bought their tickets.

37.

We hear the sound of an airplane overhead and her daughter-in-law says *binládin*, presumably a catchword that has entered the language following the attack on the Twin Towers, binládin and airplane, binládin, yobtimať, sonovabič.

Iľka asks if it's a Turkish plane and then recalls how, during the war, they could tell the planes that dropped bombs from the rest by the sound they made: the ones carrying big bombs produced a louder roar. But maybe it's just something she heard people say, she couldn't have been more than five. Who knows?

As he recalled the bombing of Dresden, Georg Baselitz, the German painter born in the same year as Iľka, said that when it was over, as he was walking with his mother among the ruins of the city, he ran onto something, a pile of rubble, and suddenly realized that he was standing on a dead woman and her baby. A childhood memory. Later he painted Hitler and hung his paintings upside down.

Iľka's clearest memories come from the second half of the fifties. She no longer remembers the drought of 1946, straight after the war, when there was no harvest and everything had to be brought in; she doesn't remember the men who volunteered for work in the Jáchymov uranium mines but when they returned, some came with bricks from the ruins of houses, others came with cancer, and most with money but then came the currency reform, and suddenly fifty crowns shrank to one.

Saying goodbye to our hosts was like a scene from a folklore pageant. How we should treat one another, how we shouldn't make comparisons and pass judgements.

While outside the Roma came and went, as usual.

There was a rhythm to it, a kind of ritualistic quality.

When Iľka and I say goodbye to each other, it's more spontaneous, without any formulaic phrases.

But she still insists on accompanying me at least part of the way and says she may well give up her mobile.

38.

Iľka is having another visitor. The man sitting by the stove looks a bit like her neighbour Romeo, his skin is also quite dark, he is heavily built and sports a moustache. He is in fact oversize and looks like a Roma. If Iľka were not pottering around in the kitchen, completely at ease, I would be scared. Scared of this Jano, a folk craftsman who makes valaškas, leather belts for shepherds, wooden črpáks and similar items of folk art. A colleague of Iľka's.

Jano is annoyed: he came here to buy 10 litres of žinčica, whey made of ewes' milk, but the local shepherd, the bača, got the orders mixed up and didn't have enough. Iľka lets him have some 2 litres of her own žinčica by way of consolation, though for

him that would be no more than a drop in the ocean. When he sees the žinčica, he perks up, guzzles it out of a Coca-Cola bottle and wonders what's for breakfast.

A short while ago I saw a Roma family by the stream above Iľka's house collecting water in plastic bottles, the man working, the woman sitting on the bank in a tight black lacy T-shirt with a lime-green bra showing through, three little children running around, but I'd rather not bring this up now, the subject is bound to surface of its own accord.

Jano's from Hronec.

From Hronec? My grandmother's from Osrblie. The conversation brings us closer, I pluck up some courage but only because I'm sitting by the window and he is at the far end of the kitchen.

The only way to Osrblie is via Hronec, after that there is nowhere to go, you get lost in the woods beyond Tri vody, on the slopes of Poľana, left to survive on blueberries and game.

Look at you, you're compatriots, says Iľka, and I try to get used to the idea of being a compatriot of Jano's. Me and Jano. From the same neck of the woods. What was my grandmother's name? Kobeľová. Nah, he's never come across a name like that. Names in Osrblie are different.

Schwarzbacher, for example. Oh yes, my mother's godmother was a Schwarzbacher, I chip in. I remember visiting her a couple of times, the last time about 10 years ago, probably on All Saints', at the cemetery. My grandma's mother was born Mária Mojžišová. Her husband died before her, and we never found her grave.

Apart from Jano there's only one folk master craftsman in Hronec, and none at all in Osrblie, a village without its own traditional costume. Osrblie was founded relatively recently and settled by Germans who came with the Coburgs and used to log wood for the iron mill in Hronec. For the nearest place with its own folk costume you have to go to Čierny Balog or maybe even further. Osrblie used to have a blast furnace, next to Tri vody. Coal and wood. Jano knows all about this. I know next to nothing about Osrblie. I've never given any thought to whether Osrblie had its own folk costume and, if so, what it was like.

On a photo of her with Gizela and Vilma, my great-grandmother Kobeľová, whom my mother didn't know either, is in a black blouse and a black skirt: village clothes rather than embroidered folk costume. She would have been about 40, certainly not yet 50, when the picture was taken, but she looks 80. An old woman all her life.

My grandfather was an orphan. My mother still remembered her grandfather from Osrblie but my grandmother couldn't stand it when he came to Bystrica. Family legend has it that his mother, who was said to be a beautiful young woman, as they always are in legends, had worked for a factory owner, had a baby and died. This would have been sometime in the late nineteenth century.

And here we are again, the Roma question. The Slovak president said that when the Roma have it good, so will we: but that's outrageous, they, the locals, say, it really won't do, as the Roma already have it good, have it great, whereas we, Slovaks, don't, which is why they don't get the president's point. I don't offer any comment to avoid getting into an argument with Jano the giant,

as I know what he would say: they don't want to do any work, they shoplift and thieve, and make babies just to get benefits. We are the ones who actually live with them around here.

But here we have to live with them, you know.

I learn something new about the old Šumiac settlement that burnt down. Before the Roma were issued portacabins and sold off their bunk beds, they were temporarily housed in a former day care centre, which they totally wrecked. The village people couldn't understand how it was possible to wreak so much damage in such a short space of time. There are no further details.

There's no point trying to do anything for the Roma, *did I see the House of Horrors near Brezno*? I did, it's still there, it's a well-known building that's clearly visible from the road, Route 66, between my favourite villages of Halny and Bujakovo.

It's a block of flats, three or four storeys high, with unglazed windows and women sitting in the gaping holes, overweight bodies in brightly coloured clothes. A Roma woman who got off the bus at the stop nearest to the house was wearing a T-shirt emblazoned with a logo that said Gucci, Dolce & Gabbana or perhaps Moschino.

Their neighbours haven't been able to sell their houses for years, they are worth nothing, and that's what it's like wherever the Roma move in, either you live with them or you are stuck and can't leave. Jano will explain it all to me.

But you know, we have to live with them here.

I know, and they, too, have to live here with you.

Based on what Jano says, Iľka's house is worth nothing or next to nothing. It must be hugely consequential, no longer so much for her but certainly for younger people, that they can't sell up and move away.

Take this house and all that she had been through to build it. It didn't burn down but she has burnt out. When does the feeling of resignation set in? At the age of 40? 50?

In Hronec, too, there are some Roma of course. Unfortunately, Jano adds. Hronec first had a foundry and later an enamel works. After the revolution, some doctor bought up the houses in which the Roma had lived under communism, buying them other houses in and around the village in exchange.

But the Osrblie folk, says Jano, the folk in Osrblie are a proud lot.

In their village there's not a single *Gypsy*.

A *Gypsy* family once tried to move in but their house soon burst into flame and that was that.

By accident? I ask. Actually, I didn't ask, I just stated it as a fact, though I realized this only later.

By accident.

Jano picks up my sarcastic tone. Who knows, perhaps the stove caught fire, or someone didn't put out their cigarette, or there was some other reason, he says everything using the characteristic word order of the Upper Hron valley, which makes it sound like a folk song, *by accident, by accident.*

The only plausible scenario that occurs to me at that moment is that someone deliberately set fire to the house to drive the family away. I have no concrete proof of this theory, but everyone around here knows that once one family moves in, before you know it a settlement springs up and the village is soon full of Roma.

I have no proof, it's just a sense I get from reading between the lines and from the drift of this conversation, but even that wouldn't be sufficient proof.

Sometime later I told my brother what I learnt about Osrblie, a village neither of us knows very much about. It made him laugh, that 'by accident'. He knew of a similar case. It happened in a village near Nové Mesto nad Váhom and that, in turn, reminds me of even more similar cases in Pobedim and Klčovany, places in the same part of the country. A Roma family moved to the village in 2002 and one night in the pub the local men said no, this won't do, and just as they were going home from the pub the family's house burnt down 'by accident', but this was just a rumour, not enough to press charges, but rumours do spread and I write them down. With the appropriate context.

Meanwhile Jano has come over to sit with me by the window. Ilka is making coffee, Jano would also like some, but only if she has instant, that's the only kind he drinks. I try to size him up. I've never seen anyone like him from up close: his skin is darker than a Roma's, there are black patches on his temples and elsewhere, his fingernails are thick and gnarled, the colour of yellowish bone and bluish purple in places. And the moustache, a moustache is a must, a bushy moustache across his broad face. For Jano size is what counts.

Do you think anyone would dare stand in my way?

A descendant of the Fifth Roman Legion.

Ilka makes Jano get up and points him to another chair, saying she wants to sit with us, laughs, and thanks him for making the chair nice and warm for her. She may have done it for my sake, seeing how terrified I was, and she may have remembered how scared I was the other day of her neighbour Romeo. She lifts the tablecloth and pulls out a sheet of paper with some quatrains on it and starts reading. So that's why she wanted to sit in Jano's chair.

The psychologist writes poetry and she has given Ilka some of her poems to read. I also write poetry and Ilka knows this full well: all of us here are artists of one sort or another. She doesn't ask if we are curious to hear it; besides, Ilka is an actor, used to performing in front of an unsuspecting audience and to speaking in rhyme, as if it was the most natural thing to do. In rhyming quatrains the psychologist's poems tell of her early and reluctant

retirement, followed by her move to the Czech Republic to look after her grandchildren.

We're having instant coffee with Jano from Hronec, helping ourselves to crisps, peas and chocolate biscuits. It takes a few stanzas before I realize what a crazy set-up this is—I tend to perk up in such bizarre situations.

Jano is po-faced, doesn't bat an eyelid, and neither do I, though for a different reason. The psychologist interests me and is important to me. Looking at Jano, it strikes me that this is probably the image that people in Prague have of Slovaks. People such as, no doubt, my friend Mr Šerý, a writer and a translator from French, although he's only a naturalized Prague resident, in reality he hails from Moravia.

Jano could serve as a prototype, Jano from Hronec, one of the three Slovaks who still make metal inlay for valaškas, my serendipitous find in the course of writing my field report about embroidery and my rootlessness.

39.

Let's go out, *the Gypsies are singing* out in the street, but then it turns out the music is coming from their mobiles. The sounds of Rompop meld into the settlement.

Sometimes they walk around in sizeable groups, singing and playing. That could, in principle, be quite nice, I imagine. But

no, it's not, they are shouting too loud and Iľka doesn't like it, she finds this sort of uninhibited behaviour very alien. She disapproves of it. And that's that.

On my way here I heard some singing in the heart of the village, an Upper Hron valley male choir belting it out, their voices echoing far and wide as the Upper Hron polyphony is meant to echo across the valleys. Eventually I discovered where it was coming from: the pub, of course, chlopi, village men.

Gazing mournfully into their shot glasses as if forced to knock them back one after the other. Against their will. They don't really want to. But they have to.

40.

I'm nearly done with my zadník, the back. Only one last strip left, I left too big a gap when working at home and expect Iľka to point it out to me. So, what's next?

The main section, the large florals. Did I bring the bandage?

No, I forgot all about it even though Iľka explained on the phone that bandage makes good underlay, though not the elasticated kind—there's another type that is stiffer, kind of starched, but we can manage without it if we have to.

I copy the floral design onto a piece of see-through interfacing, and later we will put some firm canvas under it and some nylon tulle on top. The lace is another thing I forgot to bring but it would have been no good in any case, not stiff enough, and this is not the real thing anyway, just a trial run, I must practise to get the hang of it.

I wonder if I'm doing all this just because I enjoy using these sewing terms in my writing. Will I ever need them again?

We are picking colours we like, as Iľka keeps stressing that in my embroidery I should use only the colours I like. Except for blue. Or rather, I may use blue as well, but only for the tiny flowers between the big ones, the kind that grow in this area, to form a wreath on the bonnet, the tiny blue flowers being forget-me-nots; there are no big blue flowers in this region. I look closely at the other bonnets in the house: red, burgundy and pink predominate, though every other colour is also found, there's one bonnet where every flower is of a different colour, there's even a blue one but a whole bonnet in shades of blue, that's a no-no, that's unimaginable. So we have reached the end of some kind of line, at least for now.

Iľka sews the three layers together, three different kinds of fabric, and we sit here stitching, not talking, listening to the rain, the regular mountain showers, the same showers for the past eighty years.

Eighty years in the same place, that's something that will always be beyond me.

I belong to a civilization that is in flux.

But here we have to live with them.

41.

The days are drawing out now, and I leave late in the evening, after the last thunderstorm of the day, but there is still time to take a stroll around the deserted village and its environs, the swollen streams pulsate and won't submit, and neither will I, nor will the clouds, the layers of orange-coloured haze won't submit either, there's nowhere for darkness to descend, this is our time, the night must wait.

I'm passing the last house at the foot of the hill, where a bee-keeper lives, whom Ilka and her daughter-in-law call the Magyar: he hails from the south so what else should they call him? The Magyar's house is empty, just a sofa, a TV set and whitewashed walls, a lamp shining from above and the blue glare of the TV from below. I can't help but peer into this angled, plastered room and imagine being walled in there, in that space, ending up in my own personalized, tailor-made hell.

I hope I meld into the evening murk, as the man stands in his window for quite a while gazing out—where has this woman come from? Am I a *Gypsy* or not? Is he a Hungarian or isn't he? Why am I walking from the woods along the bed of the stream? Am I a human being? Or a ghost from that deserted house?

I only step out of the stream when the crickets start chirping. The moon has risen and the streetlights have been switched on, my shoes are soaked and the large pink flowers turn purple, then blue before being swallowed up by the night.

Be careful with colours in artificial light.

Colours look different at night: if you don't get everything ready in daylight, you'll have to undo the work the next morning, Iľka warns me. One thing I learnt last night is that you have to start work in the evening and continue in the morning, you have to develop your own rituals.

Today she said something I was on the verge of saying, as happens when you're comfortable sharing the silence with someone and your thoughts intertwine. As I copied a pattern, I was thinking that these preparatory tasks serve a specific purpose, they must be kept separate, allocated their special, ritual time, and Iľka picked up from there: on a Sunday afternoon. It's best to deal with these preparations on a Sunday afternoon when everything is at peace, the church service is over, Sunday lunch has been eaten, the washing up done.

42.

The old-style bonnet was known as a čipkavec, or lace bonnet, Iľka suddenly remembers, at last the time has come to talk about it. Her mother had one like that. And since she can recall it, it must have been worn at least until the end of the Second World War.

In her wedding photograph from the late fifties, Iľka is wearing the kind of bonnet I'm learning to make; perhaps the two types coexisted for a while. Iľka explains what a čipkavec looked like, she pulls out one book after another, leafing through them, looking for something, anything that would give me a better idea. I discover that a čipkavec was quite different from the contemporary bonnet, it had lace interwoven with coloured thread, but not embroidered, and it didn't boast roses or stitched bands in different hues.

A čipkavec was made from ready-made lace. In the autumn, on market day in Červená Skala, the women would stock up on everything they needed to last them all year, from lace through pots and pans to farm animals, which were sold at the far end of the market, next to the turn-off for Muráň. That was their big annual shopping trip, Iľka still remembers that time.

I wonder about the shape of those bonnets, but that doesn't seem to excite Iľka. In fact, she isn't at all interested in it. I've asked her about it several times but she doesn't care what the folk costume used to be like in the past. It's this one, the one she is wearing now, the one she knows how to make that she cares about, the čipkavec is a thing of the past. Tradition begins in the fifties.

For Iľka folk costume is living culture.

You have to stick with what is there now and forget the rest.

Lace-sellers used to buy their stocks in the mining villages. All that the women in Šumiac, maybe also in Telgárt and Vernár, had to do was weave a few coloured threads through a ready-made pattern.

But today's folk costumes are a total mess.

Or so a woman who collects folk costume told me. What did she mean by total mess? Destroyed, defiled, despoiled, perverted, violated, raped, ruined, crippled, corrupted, wrecked and bastardized, botched, bungled and butchered?

We discuss the kinds of fabric used, the colour schemes and costume jewellery. It was those who emigrated to America who started it all and later the locals began to make use of anything that was available, anything they could lay their hands on at the time, which was pyjama fabric, bandages, veils, tulle, lace, sequins. And in the sixties, when miniskirts were in fashion, the pleated skirts that form part of the folk costume grew shorter too, the skirts made of pyjama materials were above the knees.

And in Heľpa the colours mutated from the original red to full-blown pink.

What am I to make of this? If folk costume is living culture, what does it reflect? All these sequins, the pink and turquoise lace

intertwined with silver and gold thread? Before the 1989 revolution, popular TV entertainment was known as *estráda*, after the revolution that was anglicized to *show*.

These days folk costume is mainly worn by folk dance ensembles in their shows, and is no longer everyday wear. Those who do wear it want to emulate the stars, the highly stylized folk costume worn by members of the state ensembles SĽUK and Lúčnica, adapted for performance, to make it functional and easy to change into and out of, a dance outfit rather than dress: the stage can take any amount of colour and glitter.

There is no one who can teach me how to make the original bonnet—but which one is the original?

Is it the one worn before 1989? Or before the war? Or the one worn in the thirties, before the railways were built and water pipelines installed, before the Great Depression and the mass emigration to America, or before the First World War?

Or even before the end of the nineteenth century, when Šumiac burnt down? Trimmings were not allowed until serfdom was abolished, that's probably as far back as we can go. Should I learn lace-making as well, find a maker of bobbin lace to teach me? What do you foreground in a renovation project: the Renaissance features or the hallmarks of the Baroque?

What I'm interested in is Iľka; she will set my boundaries.

43.

My mother also knew how to embroider, but I never saw her doing it. We had a few examples of her needlepoint on our walls at home, even some with folk motives on canvas in muted colours, in the fashionable seventies' hues of brown, ochre and red.

The work was meticulously designed and properly finished off; in her later years she was no longer up to finishing anything.

She must have been very young when she made those, before I was born. In later years she took out a subscription to *Dorka*, a journal featuring patterns. She never cancelled her subscription and the piles grew ever bigger as she refused to throw them out, but she never used any of the patterns.

She and I have never done any kind of handicraft together, because we have never done anything whatsoever together. I did some embroidering at Grandma's: I knew only one woman who was into embroidery and she used to visit Gizela. Her name was Nela and she was also the only one who smoked. Gizela was into neither embroidery nor cigarettes. Neither of them was into reading and only one of them into writing. That one was a nun who wrote poetry.

My mother rarely addressed me by my name, more often she called me Dora. Dora, my *Gypsy* name.

Dora, Gizela's granddaughter, Gizela's second daughter.

Gizela, just like Iľka and all the other women her age, subscribed to the journal *Slovenka* and watched soap operas.

44.

Iľka's father-in-law went to America, I forget where exactly, somewhere in the South. My great-grandfather, not the one from the Upper Hron valley but the one from Kordíky, had headed for Canada. Emigrants. Migrants. Economic migrants to boot.

Once again it rolls off the tongue better when I say this in the third-person plural, the way my mother used to say it: *they had left for Canada, they started a parallel family there, they sent money home and then they came back.* This is what's tricky about the third-person plural construction: he didn't really come back in the plural, with his Canadian family, he returned on his own.

Iľka's mother-in-law had to manage without her husband. It must have been hard but once again it turns out that I've got the wrong end of the stick: the women whose husbands had left for America enjoyed a good life, they formed the upper class in the village and whenever some hard work needed to be done, they would pitch in anyway, the bigger families would help each other out.

Iľka's father-in-law found work in an enormous slaughterhouse and the job came with health insurance, but the extreme heat, the humidity and the stench made him faint repeatedly. He managed to get away with it twice and his colleagues covered for him, but when it happened a third time his boss found out and he was fired. The third time, on the third day, third time unlucky, it's now the stuff of legend.

After that he worked all over as a farm labourer, with no insurance, so those years didn't count towards his pension, which ended up being paltry. And then there were the quotas, quotas and more quotas, always.

My family's version of the American story went as follows: they ploughed all the money they earned into buying land, just land and nothing else, arable land and fields, no stories, just land, a parallel family in Canada, a legend one sentence long, end of story.

In my family every generation started from scratch, even among my closest relatives there is nothing tangible I can grab hold of, the fields turned fallow, and the photographs show my grandfather's mother with a corner of her mouth twisted into something resembling a sarcastic grin, call it cynical if you will. It's a smile that I have too, and so does my mother and my daughter, my grandfather and his brother. My grandfather even wore that smile in his coffin.

And in death his lopsided cynical smile froze on his face into an expression of joyous incredulity.

45.

Today is the last day of school, so in the morning Šumiac is abuzz. I pass a group of Roma teenagers perched on climbing frames behind the local council offices. They're around 15, some are carrying flowers for the teachers, others aren't. They're listening to Italian pop. I'm tempted to await developments, but there's nothing but endless syrupy amor, amor, amor, amor.

Amor, amor, amor, amor.

I'm sure I'll be humming this all the way home, Pohorelá, amor, amor, amor, amor; changing from bus to train in Heľpa, amor, I don't feel like walking all the way to Červená Skala, I may have to change again in Brezno and, with a bit of luck, by the time I'm on the train Margecany–Červená Skala–Banská Bystrica, amor might leave me alone.

The youths manage to drag themselves as far as the village square, where I'm waiting for them in my waterproof jacket, parked among the dolled-up Roma girls, appraising their outfits.

Platform heels, one pair red, another black with little dangly chains, a red skirt that's long at the back, short at the front, a tight minidress, dramatic make-up, they are not waiting, they are in perpetual motion as if practising walking on heels.

Amor, amor, amor, amor is approaching. The boys' outfits are similarly ambitious, the one that particularly attracts my attention

consists of blue jeans, a white shirt, light trainers, everything matching, the right size, including the metallic slim-fit jacket, the Roma boy from Šumiac wears the sleeves of his ambitious jacket foppishly rolled up and the shirt collar raised high on his neck; the lad wears it well and so do all the others. They dawdle along the village, amor passing small-scale public architecture styled as log cabins and wooden cottages: benches with wooden shingle awnings, wooden bus stops. The boys are walking away from the school.

Šumiac lads, a Latino version of Italian Superstar, but this time without hatchets.

The bus is packed, more kids get on in Pohorelská Maša, some carry plastic folders with school reports, they're sardined in the aisle between the seats before streaming out in Pohorelá, the place with the unintelligible dialect, the kids, too, speak a different language, I don't understand a word they say.

Waiting at the bus stop in Brezno on my way here, I overheard a couple chatting to a man from their village, and when the bus arrived, I realized that I couldn't recall a single coherent phrase: I hadn't a clue what they were talking about the whole time, even though initially the language didn't seem different. I'm not sure if they were speaking with a Goral or Ruthenian accent but it was more than an accent. I waited to see if they got off in Pohorelá and they did.

For a moment, I catch myself thinking that it's actually quite amazing that they even manage to coexist here, in such a small

space, being so different in so many ways. If only there were no fascists on the political landscape.

And you shut your trap.

46.

I'm learning how to live with phantom pain.

Ilka won't be my adopted grandmother, nor my adopted mother. That is not the direction this story is headed, she will remain a character in a book without a happy ending.

I'll wait to see what will emerge, what will be cast up, what I will really recall, what archives she will open. I mean my archives, not hers.

Something will happen, something will shift, whether I notice it or not, whether I write it down or not. Go over it again, like in therapy, find the appropriate technique.

Set it down next to the bonnet or wrap it up. Tie a knot in it. Put it away.

It may seem that Ilka was chosen at random but she wasn't, this wouldn't have worked with just anyone. Ilka is a real character, she is co-writing this book. Sometimes I have to stop, as I break down in tears, just as she does when she bumps up against a thorny memory.

At first I have no idea what I have struck with my shovel.

This is my version of her, and she too has her own version of me.

47.

We arrive by car. Me and my family. The infrequent, slow and smelly long-distance buses are where things really happen, but a car journey also has its rewards.

If I were on a bus I wouldn't be less than a metre away when we whizz past two young girls playing in the street, probably outside their house, and wouldn't see how absorbed they are in playing with a doll on a chair, sitting or perhaps kneeling in front of it on the ground. Oblivious of the passing traffic. Please don't let them run out into the road. Two seconds. Route 66.

The petrol stations have also been value for money, with their gift of exchanges, *They're lording it over us, young lady,* 'they' being the Gypsies. *No one gives a toss about us any more,* 'no one' being the politicians, *they're all sorted, set up, settled, rolling in it, they've made it, bought everything up,* including *this petrol station.*

But what about us? Us?!

That's the way of the world, in case I didn't know. *That's how it is, young lady.*

The protagonists of all these stories travel by bus, they reek as they chat with their fellow passengers. I hear another version of the hazelnut anecdote. The toothless *Gypsy* woman keeps getting chocolate from her grandson and goes around saying, have some hazelnuts, I can't ever have any.

Perhaps she says this to the driver, always, anywhere, perhaps even in Šumiac.

48.

I heard another joke. An old woman is waiting at the bus stop. Someone asks her: What are you waiting for? The ten o'clock bus, she says. But don't you know that the ten o'clock runs only on holidays? So? Today's my birthday! I heard this joke from the priest in Šumiac: a clean, inoffensive joke, suitable for church. An old woman, an old *Gypsy*.

Mass is celebrated every year on Úboč hill at the Stations of the Cross, but the older women aren't up to it any more, and I can see only a couple, one in a black bonnet.

A black bonnet.

A variant Iľka hasn't told me about before: black lace, no garish colours. There aren't many worshippers dressed like this, it's summer at last, even in Šumiac.

There's quite a crowd huddled on the hill under the cross. This is a Greek Catholic mass, the incense doesn't waft all the way down to me but the smell of the warm earth does, clumps of thyme beneath my feet. The fragrance emanating from the earth after summer rain in the mountains is more powerful than incense. This mass is celebrated once a year and it was when it ended that the priest told the joke.

The priest asks the congregation whether they want to hear a joke about men or about women, then saves his flock the trouble of having to choose: it'll be about old women. Next comes an announcement: the time of a cycle race due to take place in the village next week will clash with the church service, so some of the early morning services will have to be postponed, *because the flock are reluctant to get up early*, says the priest, but they should bear in mind that the song with which we start the day is the one we keep humming all day long. Amen. Amen. Amor. Amor. Amor. Not a single Roma here.

Refreshments are served, snacks shared, everyone knows everyone else, they may even be related. Consecrated wine is poured, *one sip and we'll be up on Kráľova Hoľa in no time.*

Iľka is one of those who can no longer climb up to Úboč. When I mentioned that the priest told a joke, she wanted to hear it immediately, she didn't ask about the gospel but wanted to know about the joke, yes, the priest always tells one after mass.

I can't remember what the sermon was about and Iľka didn't ask.

49.

It is summer, Šumiac is transformed, I don't recognize it, there are a few more White children around, there's some life in the village, not just in the settlement, signs of life, the beer garden is crowded in the evening, two Roma women are drinking beer through a straw.

This is perhaps the only time one can glimpse a Roma beauty in a black miniskirt and T-shirt, bare midriff, long thick tresses, lissom in high heels and red lipstick, but what's her destination? *What's our destination?* is what my daughter asks whenever she doesn't feel like walking, and I suggest: race you there. What's her destination? The village pub.

The village pub. Beer through a straw.

There's a restaurant on the first floor, a huge poster with images of halušky and pizza informs us, the corner of the poster has a folk embroidery pattern.

The village radio presents the activities, most of which take place in the square. Village life. A stonemason is coming, he'll be taking orders at the cemetery for the next two hours.

Various salespeople are announced, including a farmer selling seasonal fruit and vegetables. A fellow from Rimavská Sobota, with a scar on his face. I join the village folk at the stall he has set up in front of the community centre.

We mingle with Roma kids, and when my husband asks them their names, they come out with all sorts, the two girls and one boy have several names each, they are around six and tell me that my daughter is pretty. No child has ever said this to me before, my daughter is only slightly younger, she is used to playing with children their age and they are not given to sizing up each other like this and complimenting parents on their children's good looks.

Thank you, you're good-looking too, I tell them, and I mean it, they are good-looking, handsome kids, they look at me in disbelief, or rather, they pull faces and look at each other, which one of us does she mean, this gadjo woman who isn't from Šumiac.

We're ugly.

One of them says on behalf of them all. In the plural.

And they look each other up and down again.

No, you're not ugly, you're very good-looking children, I insist, and they just laugh and look this way and that, unsure what they're supposed to say.

We buy them a watermelon, they take it to the community centre, it's huge but they don't want any help, they are strong, too.

50.

Iľka was expecting my husband as well, she has put on her best bonnet, not the one she wears at home. But we let him go off on his own and take it easy. I now realize this might have hurt her feelings.

My daughter, whom Iľka calls Kristínka, asks lots of questions, she addresses her as Granny and Granny answers all her questions, she is nice to her though not over the top nice, she doesn't make my daughter the centre of attention. But Iľka engages with her, sings to her and recites poems; she has that kind of memory and could go on for hours. This is the first time I've heard her sing, it's not something you can learn, these lilting cadences: the dialect has left an even more powerful impression on her singing voice. I feel like I did the first time I came here and had to get used to Iľka's way of speaking.

Gizela used to sing in a different style, though she too was a fine singer and would sing all the time, but her husband couldn't stand it, so she used to sing when he was out.

More has been preserved by folk song than by folk costume.

I am losing trust in folk costume as hard evidence and beginning to consider it more like a mirror, while the language preserved in song is far less susceptible to outside influence, particularly if you've been hearing it from an early age.

And the women of Helpa, just look at the way they're decked out these days, one adds two trimmings, the second puts on three, the fourth has to put on four, all of them pink, of course, everything has to be pink, you would never see that in the old days. Never.

I've left the bonnet I've been working on at home, another disappointment. *Let's see how far you've got.* Nowhere. I've been too busy, it's the school holidays. I'll bring the bonnet next time and leave Kristínka at home. Romeo offers me a lift in his van, it smells like a cowshed: Romeo drives Iľka's daughter-in-law to the collective farm and back, the afternoon shift has finished, the cows have been milked and fed. Iľka is waiting for us in front of her house and Romeo slowly gets into his stride, just like last time.

And he is as monothematic as ever: old, young, not bad looking, who and how with whom, with me, with this young woman here, the everyday banter with the neighbours that I've come to expect from him by now.

Once I'm at Iľka's house, I can finally show her what I've got, I've been practising the large florals, which are slowly starting to look as they should, just a couple more and I can get started on the real thing. She agrees, I'm beginning to get the hang of it. Where's your needle?

You must never let a needle drop on the floor.

This was a firm rule. In the old cottage where Iľka grew up, they used to keep potatoes under the bed, the peel served as cow feed, and if a needle ended up in the peel and happened to stick in a cow's throat, it could have killed the animal.

Not a single needle gets lost in this house even now that Ilka can afford to have her lunch delivered from a restaurant every day. Not even the tiniest of needles from Karlovy Vary, the kind used for beads and sequins, with the smallest possible eye, as even those could bring about starvation.

A photo in sharp focus: in the house where Ilka grew up there was a mirror on the wall that was slightly tilted downwards, and Ilka's mother used to keep her bonnet in the gap between the wall and the back of the mirror. That was its rightful place.

But what about the black bonnet?

We both know who we're talking about: the girl who died this spring was the granddaughter of the woman in the black bonnet, she is one of the Šumiac singers, recently featured on the radio. I saw her again on my way to Ilka's.

She wears a variant of the black folk costume: a dark skirt with a black apron, known here as *šurc*, a short-sleeved black jumper and a black bonnet. It looks stylish on her, she is quite slim, in fine fettle, Gizela would have said.

Ilka also has a bonnet like that. She shows me hers: it isn't embroidered, a variation on her bonnets, the same shape, similar to the ones she wears at home, made from an old curtain, or tablecloth, or whatever offcuts were left over. This one is made of a kind of silvery-black brocade and black lace. She has never worn it.

She made herself the black bonnet when her husband died but has never worn it.

The more I get into it, the more I feel that there is no such thing as a Šumiac bonnet. The boundaries keep shifting, the only thing that remains stable is the shape, even the way it is worn nowadays is different, with hair showing, *in the old days that was unimaginable.*

Hair had to be thoroughly concealed under the bonnet so that no one could tell a blonde from a brunette, or catch sight of any hidden grey hairs, or of thinning hair, maybe also unwashed hair. An old woman all her life.

51.

We meet the first band of them halfway, in fact, the first person we meet is a fellow carrying two buckets full of blueberries, *borovnice* as Iľka calls them. This year they've been growing only on the upper slopes, from about 1,200 metres up, *but it's full of Roma up there,* they invariably pick the bushes bare, the man tells us, who else would pick the blueberries, they've been doing it for years, picking and selling the fruit, it's how they make a living. There are some loitering by the roadside even now, and in Telgárt, at the end of the settlement, we saw police harassing Roma women carrying blueberries.

We are on a hill above Pohorelá, headed for Andrejcová, and lo and behold, we soon pass a group of some 10 Roma, adults as well as children, all with buckets of some description, they are even darker than usual. It's summer, the sun is stronger in these parts and their lips, too, have turned black, Nepalese Sherpas, with buckets strapped over their backpacks.

Purple smiles, hellos.

We come across another group at the top, after passing through an area devastated by logging, more fruit pickers emerge from among dwarf mountain pine and disappear into the carpet of rosebay willowherb, shaking their heads, there's nothing left, but they are not complaining about gadjos, they tread softly as if trying not to draw attention to themselves.

Andrejcová, the mountain lodge on the ridge of the Low Tatras, is picturesque, with flowerpots in the windows, their own craft beer, a pond and a spring, the sun beating down and good visibility after the evening thunderstorm. The couple who run it offer the Roma some of their beer, the proceeds will help rescue the capercaillie, there's beer and biscuits, the Roma settle down on the ground even though some benches are free, there is no one up here apart from us.

This is the first time I come across anyone who treats the Roma decently. I wait to see what happens while doing my bit to rescue the capercaillie by drinking beer in the sun. The Roma contribute by carrying a barrel of beer from the car, although

that's probably not what it's all about, but I still have my suspicions and wonder what will be expected of them in return for the beer.

One of the Roma is not sure if he can even have any beer as he's on blood-pressure medication. Gradually the details emerge: the man who runs the lodge is a member of an ambulance crew, probably in Brezno, and chides one of the women for ringing A&E every night.

The woman, Drahuša, is thin and bony, with childlike eyes. To me she looks about 45 though in fact she is only 32, she is a diabetic and phones A&E every night to complain about her high blood sugar. The man treats them well, and what this is really about is trying to prevent another burglary: the lodge has been burgled once, and the paramedic-cum-lodge manager wants to be on good terms with them, in the hope that perhaps one day they will tell him who was responsible.

52.

Grandma had a brother?

Asked my brother when I said I thought it was strange that we don't know anything about him. His name was Milan.

Gizela had godparents who had no children and brought her up as their own. Another thing I know is that they died within three or four weeks of each other. Gizela had always thought this

was the ultimate proof of their love, but she never told us the names of her substitute parents.

What else do we know about her life during the war? There were Germans in Osrblie, Gizela was about 15 and fancied one of them, a good-looking blond lad. Then my brother remembered another story.

As the Germans were leaving the village, one pointed a gun at the family lined up in the barn but then changed his mind and let them live.

I seem to remember hearing this story before, I have heard all her stories, but I was too young. Gizela used to tell me everything: I would sit in the kitchen while she reminisced, but I wasn't really supposed to know anything yet and I forgot it all. For instance, how scared she was when the German stood there pointing his gun at them. Had I been older I would have understood how frightening that must have been and the kind of memories this triggered and I would have asked her about it just like I'm asking Ilka now, except that during the war she was 10 years younger than Gizela.

About the same time, the Germans set up their field kitchen in the house of Ilka's parents. They were unable to communicate even though they all slept in the same room: Ilka, her sister and her mother sharing the bed, the soldiers on the floor, her father somewhere in Ukraine, by then perhaps in a hospital in Uzhgorod.

So there they were, three women and these men who were complete strangers, yet never harmed them in any way. A child's memory: her sister would steal biscuits from them, which she hid in her blouse, not a bit scared. One of the German soldiers tried to tell them somehow that he had children back home who were the same age. Iľka demonstrated the German's gestures, exactly as she remembered.

Then came the Romanians. One resembled a lad from the village, and this lad's father would go and stare at the Romanian, since his own son was away in the war. And then, finally, there came the Hungarians. They didn't ask any questions, just grabbed whatever they fancied.

Iľka used to take the geese out to graze, several gaggles belonging to more than one household. When airplanes flew overhead, all the geese ran to one place and once the planes had passed, the geese split up again, always into their own particular gaggle and little Iľka always wondered how they knew exactly which geese they should be with. No one keeps geese in Šumiac any more. Eiderdowns have long gone, replaced by duvets.

Gizela never told us any of this.

No details. Perhaps her memory was sealed or my own, a child's, wasn't capable of registering what hers was trying to communicate, and so we passed each other like ships in the night, and without my brother even more would have been lost.

But meanwhile 10 years passed, between her fancying the German lad and my grandfather. Hers was a forced marriage, a marriage out of spite, and it never struck us as odd that we knew nothing about this period, those formative 10 years that passed without any mention of being in love, not even platonically. After she married, there was her friendship with a neighbour, that was the person Gizela had been closest to, a woman who never married and became my godmother because she was observant and there was no one in the family who could be trusted with this role, even though we had plenty of relatives in the Upper Hron valley. The two women were closer to each other than to anyone else—it was the only genuine relationship of these two elderly ladies living in the centre of Banská Bystrica, together in church every morning with me squeezed between them, between their woollen coats and their let-out dresses, let-out meaning made looser and more comfortable.

After I grew up it occurred to me that there may have been something more to it, another orientation, these were the two women who gave me my Catholic upbringing, right up to confirmation. But later I grew out of that as well.

53.

This water is magical.

How do its magical qualities manifest themselves? The woman serving us in the cafeteria under Muráň Castle is addressing my husband, apparently I'm less trustworthy. *You must believe*, she tells him almost in a whisper. She's trying to act all mysterious; perhaps she is not 65 at all, but 138 and just well preserved for her age, this being solely attributable to the magical effect of the water from the spring by the castle on Cigánka Hill. Perhaps she was the daughter of the head forester who worked in this building now housing the cafeteria, formerly the main administrative building of the Coburg estate, and the Bulgarian Czar Ferdinand Maximilian used to frequent the premises because of her. Just because of her.

You must believe.

The Czar used to visit her after the death of his wife, Maria Luisa of Bourbon-Parma, and after Princess Eleonore Reuss of Köstritz, too, died 10 years later. He would park his automobile, having tossed sweets and money to children on the way, the vehicle had to be hauled all the way up Kráľova Hoľa by the young lads from the Hron valley. This is the first time I've seen his car, on a hoarding it looks more like a carriage but it was indeed a car, as getting to the summit of Kráľova Hoľa in a horse-drawn carriage would have been beneath the Czar's dignity, so the only solution was manpower, strapping young lads from the Upper Hron valley, maybe from Šumiac as Hrúz suggests. And one more factoid: it was a Daimler-Benz. The first car on Kráľova Hoľa.

The lads were more likely to have come from Telgárt or Vernár, young men recruited by Pavol Spišák, a Greek Catholic priest and translator in Telgárt and, later, Vernár, he would have happily done this for his benefactor Ferdinand who had given him the gift of education and ultimately also of a couple of years in prison in the fifties, when the communists disbanded the Greek Catholic church. Hrúz doesn't say this, this last bit is my conjecture.

Who knows whether Ferdinand really kept tossing coins and sweets to children while being carried up to Kráľova Hoľa in his automobile?

Iľka can't possibly remember this, nor could Hrúz, who was blacklisted under normalization and exiled to a job at the transmitter, but Klára Jarunková, who saw Ferdinand in the market in Červená Skala, might have. We could have a chat about the difference between strong young men from the Upper Hron valley and chlopi from Šumiac.

Ferdinand didn't meet his maker in the bosom of the beautiful Muráň countryside as he would have preferred, though in the end he did manage to have the manor house in Predná Hora built, complete with 365 windows, like the one in Svätý Anton which, according to Iľka, boasts 52 rooms, 12 chimneys, 7 porticos and 4 entrances for the bones of Ferdinand, who was worth 18 human beings, since he knew 18 languages.

You must believe.

We are in the woods, and my daughter says that now *we're inside a book.* As we come out of the woods, she says we've just come out of the book.

The woods were dark, and there was a place right in the middle where we couldn't hear a sound except for our own breath, our own footsteps, and our voices asking why it had suddenly gone so quiet. How odd that we can't hear anything here, no birds, no wind, no rustling of leaves, or even the chirping of night-time insects. This was just below the spring.

Let's stop whispering.

54.

The last time I was here Iľka was unwell, she had stomach ache, something didn't agree with her; perhaps it was her medications. She was in a lot of pain. *But apart from the pain I'm fine,* she says, except that this time she says she did think it might be the end.

That was something I'd forgotten about, that the end could come at any moment. But there are those who are constantly aware of death and are always good-natured, knowing that every meeting could be their last.

Unlike me, Iľka does think of death. I have underestimated death once before, and when it happened we all said: but it hadn't looked so serious, it was so unexpected, how could it have happened so quickly. That was how Gizela departed this world, just the way she had planned. A sudden departure brings no closure.

And what I, Dora, Gizela's granddaughter, remember, is that their last meeting was also her first meeting with Gizela's daughter Miroslava in a long time.

I also remember that Gizela complimented Dora that the coat made her look šlangovná, slim.

That may have been the last thing Gizela said to Dora. Dora doesn't remember anything that was said later, but that didn't strike her as a particularly kind thing to say, Gizela might just as well have said *I haven't seen you here for ages*, which only goes to show that Dora feels guilty because the only thing Gizela said to her was that the coat made her look šlangovná. Kindliness wasn't typical of our family, but caring was: as a carer Gizela was beyond compare, but caring doesn't necessarily equal kindliness.

Sometimes I talk to Gizela, sometimes to Dora, sometimes to both of them.

55.

Iľka showed me a bonnet to which I hadn't paid much attention before, as both its zadník and the stitched chain were machine-made and the only thing that felt right about it were the colours. The embroidery seemed different too but it was only now that I noticed it had more blue than any bonnet I'd seen. The flowers were blue, purple and yellow-brown, very understated, no neon colours, no sequins, the only thing that jarred was the machine stitching.

I tried it on and it was a very good fit, almost as if it had been made for me. I don't know who made it: it wasn't Iľka. Perhaps it was Karolína, Mária Károlyová who is no longer alive, she just went and died, leaving the bonnet behind.

The bonnet is not stiffened, and the only piece of card Iľka can find is an Easter postcard with a picture of Jesus. She has wound some yellow thread around it, and will now use it in my bonnet, attaching it to my head using her own hair clips as always.

I have Jesus under my bonnet.

I appraise myself in the mirror attached to the water boiler above the wash basin, the Ten Commandments behind me, no Igor, Igor is on holiday, staying with Iľka's brother.

I like this version of folklore, a bonnet stiffened with a bandage, *the firmer kind, not the elasticated kind,* as Iľka never fails to stress, and with a postcard with Jesus, a bonnet partly embroidered by

machine, an imperfect bonnet like all the others, a bonnet made with offcuts of the everyday bits of fabric lying around the house, patched together from whatever material was at hand. For we are in the mountains, in this godforsaken part of the country unknown to much of the world.

56.

In Šumiac you can watch thunderstorms approaching as if you were in an auditorium. You don't even have to climb up to Úboč or above the beekeeper's house, it's enough to stay in the village and open the window. They come creeping in from the Muráň Plain or the Vepor Mountains and Poľana, but I scurried out anyway to meet the dark clouds outside, to the nearest meadow, with hell still far away: we'd been waiting for it to break loose all day but it didn't arrive until the evening. I went to meet the clouds so that I could see the bolts of lightning stab at the countryside: when you're so high up, you feel as if you owned the countryside simply because it's in full view. A minute later I was racing back to the house, running like the wind, as the raindrops were huge. I watched the rest from the porch.

Each mountain thunderstorm of this kind increases your trust in nature, with its incredible capacity to come back to life completely unchanged, everything being the same as before, and the earth fragrant until something happens and the surging streams sweep away everything in their path.

That's when trust turns to dread.

And in due course the flow of water abates and fear finds its own path, its own riverbeds and meanders, rippling below the surface or booming into the delta, until a combination of circumstances brings it spurting out like a geyser.

57.

The village school is being refurbished. It will get a lick of orange paint before the children return on Monday. The first house in the village that welcomes the visitor is candy-pink and peppermint-green. The paint's on special offer, my husband says.

Whatever each one had, whatever each one could afford.

I haven't done any stitching, I have little to show Iľka, all I did was put some finishing touches to the roses in the central section. I am showing her the photos I took at the museum in Brezno. I dropped in almost on a whim and found just one wedding bonnet from Telgárt on display. The back had a lace underlay, probably cotton lace. I took a picture of it through the glass. The pattern is similar to the one Iľka has taught me, the middle section is made of brocade covered in the same lace as the back, while the front is bobbin lace. It's white with green, yellow and purple yarn threaded through the holes. A good mix. This is it, Iľka recalls it.

A čipkavec.

Summer is not yet quite over but I see straight away that Iľka has switched to a different mode, she is on her own, the owners of holiday cottages, the locals' grandsons and granddaughters have gone, the tenor has started a new season at the theatre. An Indian summer, lime green, pink, orange and here and there, lime plaster and wooden cottages. I would like to make a bonnet in these colours.

A bonnet in colours on special offer.

58.

One of your daughters-in-law will love you but the other would kill you at the drop of a hat.

The man from Košice had foretold Iľka.

We are in the early seventies, when an annexe to the TV transmitter tower was being built. Iľka had recently had a baby and was having her house refurbished. She took a summer job at the Villa Maliter where the builders were accommodated, serving breakfast and dinner in the canteen. She was still young and quite scared of them, as she keeps stressing. All on her own, with men on week-long shifts, thrown together from all over Slovakia: even now, half a century later, she can still recall every one of them.

She can see herself at the counter again wondering who will turn up next, what state of mind he'll be in, who got up on the wrong side of the bed, what he will say to her, who will be hung over or rather, who won't, who will be nasty to her and who will crack jokes: the workers' faces roll before her eyes like credits on TV. Her memory is overlaid by a film from the seventies.

She would spend the mornings and the evenings shivering with fear in the Villa Maliter, while her house was being built during the day, a slight figure of a woman having to put up with the village folk saying how lucky she was to be the one who wore the trousers. Iľka has a ready response.

Trousers are hard to wear. Especially if you're a woman.

I wonder what kind of bonnet she used to wear in those days. The Villa Maliter was nationalized and no longer belonged to Klára Jarunková's family.

Iľka tells the story of a Hungarian who couldn't speak Slovak properly and regularly lost his week's wages at cards, playing with his Slovak fellow workers. He couldn't afford the fare back home so his foreman arranged for Iľka to lend him the money from the till, leaving his ID as security. But snow fell on Kráľova Hoľa that weekend, the building work ground to a halt, cars couldn't make it up the hill and the ID stayed in Šumiac. But the Hungarian managed to send the money through somehow and they sent him his ID back.

Then there was the man from Košice. His name was Zajac. He sported a beard at dinnertime though he didn't yet have one at breakfast.

Did this man Zajac really manage to grow a beard in the course of a single day? On Kráľova Hoľa, of all places?

So this newly bearded Zajac said to her: show me your palm, let me tell your fortune.

In front of an audience, with all the men watching, Iľka thrust her hand out, laughing, it wasn't meant to be serious, she had no idea that she would still remember it half a century later, down to the last detail, that she would keep coming back to that man from Košice who grew a beard in the course of a single shift on Kráľova Hoľa, back to the moment she thrust her hand out of a TV set. The moment the bearded Zajac told her that her parents hadn't given her a chance to take her own decisions about her life.

First they didn't let you go to school, and then they married you off. Twice more you will fall on hard times. I can't tell you when exactly. And you'll have lots of laundry to do today.

When Iľka came home, she found that her son had wet himself in kindergarten. She hadn't planned to do any washing that day but now she had to.

The next day the man from Košice asked her: Did you do the laundry? I did.

He knew that she had done the laundry, he knew that she had sold a cow because she needed the money to build her house, and he also knew that one of her daughters-in-law would love her and the other would kill her at the drop of a hat.

When you're young, you must expect to fall on hard times sometimes; these things happen, and the fall is always harder for you than for others.

When Iľka's father hanged himself, she remembered the bearded man from Košice. The first bad thing.

By then she had discovered that Zajac from Košice had a twin brother without a beard.

The memories are in sharp focus, every detail crystal clear. Her sister-in-law turning up at the shop, the two of them going to her parents' house, still with no idea of what had happened. Finding her father hanging in the outbuilding.

Her sister-in-law cut him down as she held his body.

For her everything came to an end. Iľka's life had depended on her father's. Now I understand.

After he died, she didn't shed a tear for three years. For the next seven, she couldn't stop crying.

And after the seven years were over came the burnout and the hospitalization in Podbrezová, and then the Velvet Revolution, which she doesn't remember for these reasons.

And all those myths that collect around the death of a loved one and imprint themselves in one's memory forever, moments that might otherwise seem insignificant.

How her father sent his wife over to his daughter's because she needed some help and he wanted to be left alone. Or the dream an old schoolmate of hers, a communist then living in Revúca, had the night before Iľka's father died, in which Iľka's father told the schoolmate that he wouldn't finish the work around the house or the garden.

All the tell-tale signs that had gone unnoticed. The lingering question of whether and indeed how it might have been prevented. The men in the village used to come to her father to have their hair cut, while the women came whenever a pot needed mending. But suddenly one day he flung one woman's pot over the *dach*, the roof. Out of the blue. They sensed that something was brewing. Iľka and her sister, who worked in Predná Hora, took their father to see a psychologist, who said it was burnout but didn't know what to do about it.

Now Iľka associates all this with the man from Košice, the Villa Maliter and the construction of the annexe to the transmitter.

A suicide in the family was unacceptable in the village; everyone knows that in the old days they wouldn't allow suicides even to be buried in the cemetery.

Families would hush it up.

Not so Iľka, who decided to speak out, as people were bound to find out sooner or later anyway, this happens *in every single family*, not just every single house but every family, she argues, *in every single extended family*. She is still racked with guilt. She keeps turning over in her head the question of passing judgement. Passing judgement on the families of suicides. She has been pondering this. For decades now.

Iľka replays in her mind all the suicides she has ever come across. She was the last person to see alive a man who came to the grocer's. Then there was a lad who worked at the haberdasher's in Karlovy Vary, the one where she bought the needles with minuscule eyes that she has given me. She had been there a few times and one day she was told that *the lad has taken his own life*.

And her cousin, another tragedy: he also died by his own hand, a double stigma. It was the suicides that the man from Košice had in mind. More guilt.

But it happens in every family.

She's probably right about it happening in every family, it's happened in mine too: first the husband of Gizela's sister Vilma,

then her son. Not counting those who drank themselves to death, like my mother's cousin who took to drink because she was grieving for her husband, who had also drunk himself to his grave. Adding them up, there are four in my family.

Actually, there is one more story, it's to do with my mother and her mother, Gizela. Each had her own version of what happened when Gizela wanted to take her own life. In fact, not only her own but her children's too. We no longer know how, because if we did, it would make the event almost real and we could never cope with that.

Perhaps Gizela herself could not have been able to say how, all we can be sure of is that it was my mother who intervened. Mum told her that they couldn't leave my father on his own. We don't know how old my mother was at the time, how she knew what was about to happen, she no longer knows herself—all we know is that Gizela came to her senses and in the end nothing happened. That's the family legend. We will never learn how the children processed this, but one thing is certain, our suicide score is four successful ones versus one failed. The unofficial results are yet to be announced.

But Ilka handled it really well and we agree that it could have been a lot worse. What might Ilka's father have been through, how had his memories affected his life? The trenches in Ukraine, the hospital in Uzhgorod? What had he seen there?

More recent memories carry less weight, liable to be blown away by the slightest breeze.

One thing I'm sure Iľka won't remember is the helicopter that landed on the football pitch yesterday. This time it wasn't Slota coming to have his fortune told, as the pitch was swarming with police and police dogs. Apparently a biker had been in an accident on Predná Hora and there was nowhere else for the chopper to land. Later it turns out that the accident happened in Červená Skala, and I also learn the name of the local mafioso and that this was in fact a raid. The Roma insist that the police didn't show their faces in the settlement and that this was nothing to do with them, and according to yet another version the police had arrived in the village in the morning, long before the accident happened. How on earth could I have picked up so many versions?

59.

I'm in a museum that is only 15 years older than I am. But it won't take me very far into the past, as its oldest acquisitions date only to the late sixties. The plaster on the wall behind the display is peeling, the bonnets are here before me, about 20 of them. I'm allowed to take them in my hands and feel how solid they are, how musty they smell, how dirty and grimy and uncared-for they are in the boxes they're kept in; they're just like the ones Iľka

sometimes shows me. Three are of the čipkavec variety, the one I saw on display last summer being probably the finest and most valuable, in all likelihood the museum's outstanding specimen.

The bonnets are patched together from whatever was to hand, the more recent they are, the less attractive. A bonnet made in the seventies, for instance, is similar to Iľka's daughter-in-law's from the eighties but more subdued; though it has brightly coloured pompoms, they are not too big, and also lots of costume jewellery but not so much that it would cover all the embroidery. Neon colours already make an appearance on this bonnet, on the ribbons and bows, while the bonnets made in the fifties and sixties are still free of such ornamentation. These continue to mushroom with every passing decade, becoming ever more baroque, the colours ever more lurid, something being constantly added, the original proportions gradually disappearing.

I come across some material suitable for bonnet-making, a sturdy piece of embroidered tulle, sky blue lace interwoven with coloured threads, donated by Iľka, according to the label. This is just like her, all her boxes and bags crammed full of bits and bobs, bonnet parts embroidered by someone who is no longer alive.

Purchased sometime between 1922 and 1940 in Červená Skala.

She had only just been born in 1940 so it must have been her mother who bought it. The tulle is starched, coarse, pale blue cotton. She didn't want to keep it and donated it to the museum in 2005, the year her mother died.

I show the photos to Iľka. She has something to say about each of them: this one is from Telgárt, that one from Šumiac; there's one we find particularly appealing: greyish-blue with dusty-pink florals, a highly atypical colour combination for folk crafts locally, then we discover another with the same pattern as the one I'm making right now.

The bonnets are decorated with wreaths of flowers of every kind, wreaths of blossoms that have grown out of soil besprinkled with mothers' tears, as the poet Maša Haľamová might have put it. The poet Ján Buzássy might go further: the parched soil will be soaked in women's tears and thus have its fertility restored. Notions that run deep. We're knee-deep in poetry, in the national canon. And then you have the folk sayings: beating your wife is like tilling the soil. I could go on and on. You shut your trap. I have to stop, this is going too far.

I read out the names of the bonnets' former owners. Mária Petrová. Iľka gives a laugh. She was an embroiderer, but her husband flew into a rage whenever people from the museum came to see her.

She would let them photograph her in folk costume only if her chlop was not at home.

It sounds like an amusing story, one that rings true. But where exactly did it happen? Was she photographed in the yard, or out in the fields—more likely the latter, as there wouldn't have been enough light indoors. Did a neighbour rat on her and tell her husband that the museum people had been again? Did she get a

146

beating? Did she have to wait for her exhausted, drunken husband to collapse into bed, like Iľka had to before she could sneak out to a rehearsal, or stay up all night reading? Are there any old wives' tales which say that if you let yourself be photographed for the museum, you will bear ugly children, your fingers will rot off or your cow will die?

Júlia Marníková.

A perfectly white bonnet to fit a small head, made of white, patterned nylon, with the traditional shape maintained, the back, zadník, see-through, the front of lace: meticulous, painstaking and delicate work, an unusual marriage of nylon and bobbin lace. No embroidery. The lace is not threaded through but sown on just as it was bought at the market in Červená Skala, lace from Staré Hory or Brusno, perhaps Špania Dolina. I don't think it has seen much wear. If I hadn't photographed it, we wouldn't have discovered so much about it, and yet it's the bonnet I remember best.

This is my mother. An unemotional tone, no sense of surprise.

Iľka didn't remember her mother's bonnet, she didn't even remember donating a large quantity of lace to the museum 12 years ago.

These are relatively recent memories, less vivid than those from the fifties and sixties, she's beginning to forget my visits, doesn't remember what she has already told me, I've heard several things twice by now.

The bonnets that belonged to Iľka and her mother are among the museum's oldest and least typical.

When Iľka talks about her mother, it's as if she were still alive, distance is a concept that is alien to her, and this also seems to have affected her perception of death.

The next world is near, it's right here, just behind the fence, on the far side of the wall.

Iľka's mother died the same year as Gizela, my second mother, my grandmother, so both Iľka and I lost our mothers in the same year: hers lived to be 91, outliving by a quarter of a century her husband, who hanged himself.

Iľka's mother's father Marník was a sexton who lived to be 96, despite having been hauled off to Siberia as a young man during the Great War, to Verkhoyansk, the third coldest place on earth.

Every year, even in his ripe old age, he went on the pilgrimage to Levoča, to beg for forgiveness, she adds, perhaps because this was something he kept repeating, though only he knew what he needed to be forgiven for.

60.

I like eavesdropping on conversations at the bus stops. If you regularly visit this place over several months, you learn a great deal. There's a woman who travels regularly to Austria where she

works as a carer, sharing the job with a woman from Čadca. The trick is to not draw the short straw and end up being on duty during the holidays.

There isn't much I can pick up when the Roma talk: their language, accompanied by extravagant Mediterranean gestures, is alien to me, and I don't understand a word, except the odd Slovak word they throw in.

I'm in luck: one of the women switches to Slovak, gesticulating wildly, I can't tell how old she might be. There are sores around her mouth, white patches.

See them iron bars?

When she comes to retelling a conversation in Slovak, she doesn't translate it into Romani. *Yes I see them, I said. So tell your husband*, she says, then switches languages unexpectedly so I never find out what the other woman was to tell her husband, then she says *papers*, another word in Slovak, A hybrid sentence follows: *Sure as hell, hareštem*, I manage to guess that someone has been nicked, but then it's back to Romani. Every now and then she casts a glance at me, I smile back and realize it doesn't occur to her that I can't understand.

The women get off at my stop in Šumiac, the one who was talking to the one with the sores about prison sets out in the same direction as me. Although we are headed the same way, she is keen to get away from me. She lights a cigarette edgily at the bus stop and then hurries down the road in the direction of Iľka's house, towards the settlement.

61.

Where have I gone wrong now? I can't seem to get the hang of this. Back at home I got started on the bonnet's hem, the chain. A waste of time, it looks dreadful. It seems so easy, yet I just can't do it. Iľka notices that I cut the tulle the wrong way, she helps me to prep another piece and a few minutes later it's much easier, coming along quickly and nicely. One row already done.

A song on the village radio is being played for those whose birthday it is today. It's a Romani song, perhaps 'Hej, romale'. A lovely song, I say, but Iľka *doesn't like these Gypsy songs*, she loves Slovak and Russian ones, not this, thank you very much.

A song for Viera Pokošová on her fiftieth birthday. The Pokoš family from Šumiac are the best-known Roma musicians in the Upper Hron valley, grandchildren of the legendary Edo Pokoš and sons of Bartolomej Pokoš. Berto and his family recently moved to the nearby village of Vaľkovňa. Why don't you open the window, Iľka says, seeing that I'm pricking up my ears to hear the loud-speakers.

Iľka sings to me: 'Vecherniy zvon', 'The Evening Bell Tolls', in Russian. She doesn't mind that, it's a language she likes and under-stands. Then she sings the ballad of Anička, a girl who has died and her sweetheart is sobbing over her grave.

Russian is the only foreign language she understands. Her only window on the world. She never studied it, she just picked it up.

The last song she sings for me is 'Išlo dievča k spovedi', about a girl going to confession, the song they chose to sing at an event celebrating the anniversary of the Great October Socialist Revolution. The Šumiac way.

We wait to hear if the funeral of Iľka's schoolfriend will be announced on the radio. She died just short of her eightieth birthday. Iľka will be eighty in a few months, but the way she reacts to death in any shape or form always takes me by surprise. She never shows any emotion.

Iľka is now the only elderly person in my life and I've forgotten that this is indeed a possible way of dealing with death.

Iľka and her friend used to lend textbooks to each other, these were scarce during the war and even afterwards. And years later her friend got divorced and spent a long time bedridden in her daughter's house in Brezno before she died. The psychologist, too, is coming to the funeral.

I have almost forgotten this social aspect of funerals. That mattered to Gizela and her neighbour, the one who was my second grandmother, in actual fact my godmother. Whose turn was it now, who will attend the funeral, what will it be like? For Gizela a funeral could also mean going to a different church, walking up Dolná ulica to the Cathedral, the *German church*, or the *Slovak church*. Iľka, too, has her work cut out now, trekking up the hill, through the village to get to the Slovak church.

After she recited some ballads from Karel Jaromír Erben's *Posy* we turned on the radio. A mass of some kind was on, or rather a litany, but instead of Erben's *For myself new boots I'm sewing* we hear regular repetitions of *You who have suffered pain and torture*: the priest says something, then a male singer and the female chorus responds at regular intervals: *you who have suffered pain and torture, pain and torture.* This could be a live broadcast, Iľka and I fall silent. I'm stitching, she is making wrist warmers.

You who have suffered pain and torture.

It's like being in a trance, I can't even remember what happened next, I struggle to find the thread.

You who have suffered pain and torture. **I wonder who they had in mind.**

Perhaps a phone rang, or a dog barked, or a car came, or perhaps the mass came to an end, or I just messed up a row, and Iľka came to the rescue, *you who have suffered pain and torture*, I don't know.

I'm beginning to miss Iľka's daughter-in-law, she could give Iľka a hand. She has a big commission from the folk ensemble and would like to finish it by Christmas but apparently her daughter-in-law doesn't have the patience, she says she no longer wants to do such work. It's a shame, there'll be no more anecdotes, but then we wouldn't have heard *you who have suffered pain and torture*, wouldn't have sat in silence together, the best kind of closeness. A complete row finished in a few minutes.

62.

A girl of about five shouts at me as I walk up the hill, a guttural howl.

Back in the summer, as I was walking this way with Iľka, we passed by a smallish group. At first I thought they were a mixed Slovak-Roma family. *They're not from around here*, Iľka said. And then we heard some Spanish.

A new CCTV camera has been installed on a wooden cottage, with a notice saying that it's municipal property: I have almost forgotten that we are in a dangerous, high-risk area, from now on we'll be recorded whenever Iľka walks me to the bus stop and gives me a goodbye kiss.

Every time we part, I think of how fond I am of her voice, I want to be with that voice and have it addressing me in the gently mocking tone she employs even as she says goodbye, as if she was teasing me. It's the way she speaks to others too, Whites and Roma alike.

She sounds different when she revisits her younger days, telling her stories and not quite believing that all those things really did happen, wondering why they happened to her, why people had done those things to her, why her mother-in-law had told her husband that their baby was born with its fingers missing, why, why, why, but then she returns to the present and regains perspective.

And the mass always concludes with a joke.

63.

And where have you been gallivanting, my dear? This is my first visit in a long time. My first snow of the year. Here the first snowfall of the year came as early as October and even now there are snowflakes dancing outside.

Iľka is always composed when she tells her stories, generally starting from a long way back: she went to the cemetery to light candles on All Saints', she has many graves to light candles for, she's related to half the village, there was mud everywhere. She bumped into the mayor, who had placed an order for a pair of wrist warmers but had yet to collect them, they chatted for a while, and by the time she had done the rounds of the graves, she was exhausted, she slipped and fell, knocking her head on a gravestone. But her bonnet softened the blow, especially as the kontík was reinforced with card, since her hair is now getting rather thin. But for the bonnet, she might no longer be with us.

But Iľka is unconcerned, the mayor and his family helped her to get home, her coat has survived, the mud came out in the wash, she had a black eye and some pain for a few days, but now she's fine.

The bonnet as a crash helmet.

I'm discovering another new emotion. The fear of losing someone, or rather, the likelihood of it. A new experience. Not one I

had with my father, as I didn't know him, or with my mother, or even with Gizela, whose death I wasn't expecting at all. Besides, it happened at a time when what I needed was more distance rather than to return, I'm only now ready to go back.

But the day will come when I will ring Iľka and she won't pick up. Or there will be a call from Šumiac summoning me to her funeral. Without having been able to say goodbye. It's not likely that I will get the chance. I am grateful to still have someone, grateful that I can be here and experience it, grateful, even if it's temporary.

It's a pity you don't live here, she says.

64.

So what did you discover?

What did I discover?

I've forgotten that the last time I was here I showed her the photos I took at the museum, like some scholar, but Iľka wasn't all that interested.

I didn't do any research this time. There were elections and it turned out that in Šumiac the people again voted for a fascist as regional governor, the only village on Route 66 to do so.

One hundred and forty individuals, to be precise, out of a thousand eligible voters.

And this in a village with a history of anti-Nazi resistance, with street names such as Partisan Street and Captain Šverma Street, a village that produced many partisans, some of whom lost their lives in the Slovak National Uprising or in concentration camps. That's what I discovered, and it shook me.

Iľka didn't vote, young people were the ones who turned out to vote, she tells me, same as in Kľak, the village the Nazis had razed to the ground. She has this knack of being able to home in on what really matters: it's nothing to do with education, it's more a question of intelligence. Iľka doesn't vote unless she knows the candidate personally, so she only takes part in local elections. Fair enough, that's a legitimate point of view, even if this time it happened to benefit the fascists. But she doesn't feel sufficiently competent to make a choice.

We are back on the subject of her lack of education, as she links that even with going to the ballot box. To some extent that may be an excuse but the fact is that Iľka has been unhappy for years because—for example—she can't answer every single question in the quizzes on TV.

The locals voted for a fascist because he was on offer, they could take their pick, like they do when shopping in a supermarket: deep-frozen pizza, instant coffee or Kinder Eggs.

Who are the 142 people who voted for the fascists in Šumiac?

The Milgram experiment showed that up to 90 people out of 140 would be prepared to administer a lethal electric shock to their victims. If they are ordered to. If made to hold the victim's hand, 40 people would be prepared to do so.

While repeating, we were just following orders, we were just following orders.

As did Eichmann who organized the deportation of 7,500 Hungarian Jews to the territories ceded to Hungary, together with Slovakia's interior minister Šaňo Mach. In the year Iľka was born, just a few kilometres south of Kráľova Hoľa. Then Eichmann carried on. And on.

Could 40 people be found in this village prepared to burn down the Roma settlement if they were told that it was the right thing to do? If someone egged them on, gave the order, organized them into a militia?

Not if any of them refused. As the Milgram experiment showed, the figure of forty would dwindle to five.

Five people would be enough to burn down a Roma village, just as happened in Pobedim and Klčovany. And in years to come, the folk of Šumiac would be described as a proud lot, like those in Osrblie.

But here we have to live with them.

65.

This is something I was going to give you last time you came, she says, but I forgot. The back section of a bonnet. She got it from Telgárt, where it had been stowed in a chest, it could be a hundred years old, cotton tulle lace from Červená Skala. I will treasure it: she knows I'm the only person who would appreciate it.

I have tracked this bonnet down. I know how it acquired its present look.

It's the pale blue tulle that gave it this shape. I saw a white one like this in the museum, with flowers in the same colour and done in simple chain stitch, hemmed with multicoloured cordonnet, that's what gave the bonnet its firm shape and also served as the underlay. The patterns we have today have all evolved from that.

But if that is the case, why did they switch to material used for curtains? They could have stuck to tulle, even if it was synthetic, using cotton thread to outline the pattern, and then starching and hemming it the traditional way.

Why has it come to this, making it so much more difficult to ensure the lace is firm enough? Now the fabric needs to be reinforced with some other material, so that the stitching is firm and the tulle underneath is visible, one mustn't cut into the stitches. That's what I'm struggling with now.

Perhaps tulle was in short supply under socialism, like many other goods. Such as toilet paper or bandages.

Why has no one reverted to the old style? Folk costume is constantly and rapidly evolving. Sometimes it takes only one woman to dare to try something different. Was it Karolína? Was it Mária Petrová, whose husband wouldn't let her be photographed?

Sometimes I feel that Iľka is encouraging me to be a bit careless in my technique, for example, when you cut the embroidered lace like I'm doing now, it's impossible to get the scissors in everywhere, though it would be just as straightforward to embroider the flower stems later.

Well, do it any way you like.

For her part, she won't be changing how she does it. I can't tell whether she is really happy for me to do it my way, or if she is offended that I'm not following her technique. However, she is very easy-going when it comes to colours, they are important up to a point, although I'm increasingly less clear about where that point is. Having visited the museum I'm not even sure that there is a particular point.

We both find ourselves making mistakes. I spend more time fixing them and having to undo what I have done than making progress.

Stitching makes us fall silent.

That rhythm particular to working together. An unexpected moment of immersion that feels quite natural to both of us.

66.

The other day we couldn't recall the name of the village, but now it occurs to us: Varín. Had Iľka been allowed to marry the man from Varín she would have been living by the river Váh, maybe in Terchová, or Žilina, in Vrútky or Martin, and only visited Šumiac every now and then.

Via Šurec or Boca or Vernár.

He was thirty, she was twenty. Ten years later a letter landed in Šumiac, she'd given birth to her second son by then. It was addressed to her father but was delivered to the wrong address, as her father shared his surname with two others in Šumiac. After reading the letter, they told the postwoman to take it directly to Iľka.

Iľka read the letter. The man from Varín was asking her father, after so many years, how his daughter was and why he had opposed their marriage. Iľka showed the letter to her father and he told her to throw it away and, above all, not to reply. Iľka did as she was told. As she had always done. The Fourth Commandment. Thou Shalt Not Kill is only the fifth.

After telling me this story she paused dramatically and then said, oh well. More silence, followed by a sigh, then another *oh well*. I may have chipped in with *but that's horrible* or some similar banal nonsense, I no longer remember, the nonsense you spout yourself is the hardest to recall. So, no, I really don't remember.

When you're leaving the door is wide, but when you return it's rather narrow.

A metaphor that sums up the story of Iľka's life.

67.

I like it when she is showing me things. All those bundles and packages of hers. This is the headscarf in which she had kept his letters, the letters from the man from Varín, when they were still in touch; she left them at her parents' house. By the time she had a house of her own and got the bundle back, the letters were gone, thrown away or, rather, incinerated, as letters usually are.

Now she keeps various documents bundled up in this scarf, such as photos from old IDs. The older Iľka wears glasses, the younger Iľka doesn't.

Her vocational certificate, which she had to earn while already working.

A document testifying that she had voluntarily handed her property over to the collective farm, just under 3 hectares as well as one cow, dated 1975, 30 years after the war, almost 30 years after the onset of communism and not quite 15 before the Velvet Revolution. Living out most of the totalitarian period under a kind of ad hoc system, not quite socialism and not quite capitalism, just a straightforward tyranny of a feudal kind, an intermediate

state that had gone on too long, in this place at the end of the world that no one ever visited and where you can rely only on the members of your own family. And it's the family that ultimately takes all the decisions, including about things that should be none of its business.

It's cold outside, no one will visit Šumiac now. It's after All Saints' but still almost two months till Christmas.

Finally, she shows me some gold teeth that she keeps in a box.

So now you know everything about me.

What if she, too, has a project, which is to recall her entire life, to bring to a conclusion a work still in progress, by channelling it all through my head, as that is still capable of moulding it into a rounded whole? Her short-term memory is no longer what it used to be.

1989 was the year of her burnout, I learn almost nothing about what happened after that. Her 30-year friendship with the psychologist. A period of 30 years after the age of 50 is entirely different in intensity from one that begins at the age of 20: it is far more diluted. As for the last 10 years, there's virtually nothing: the tenor has graduated, her responsibilities are over. Nothing on record. So now you know everything about me. And I'll write it all down. She knows I've been taking notes. Maybe she likes the idea of being in a book.

But you mustn't give my name or I'll come back to haunt you.

Either she believes in life after death, or she doesn't believe that she'll live long enough to see this book. She would come back to haunt me: I first heard such stories growing up, of the soul banging on the door with a stick. Ilka is convinced it will be possible. A life behind the door.

Your name will be Ilka.

Ilka, Elenka, Ilonka. I won't call you Hela, Ela or Jelena, though I'm sure that you would like Jelena, but this is my book and the person in it won't be you. It will be only someone that I have seen, the person I can remember. You will be as I see you, as I remember you. It will consist of the images that I will need.

Ilka's life is my story. I need it in order to put together my own, my new one, from scratch. Afterwards I will rewrite these sentences, turning them into new ones that will be my own, ones that I will learn for ever, told in words of my choosing. But it will be quite a different book. It won't be about her or about me, we will be relegated to the lower levels, the intermediate layers. Only the book will remain. In and of itself. It won't be for me or for Ilka, nothing will haunt us any more, neither of us will give a shudder if someone bangs on our door with a stick.

When I write my next book, she will be sitting by my side, she will be there for each and every book I write, just as she is here now. She will say *do it any way you like* or *give it to me, let me start*

it for you. Our heads will touch. Sometimes our shoulders. Sometimes we will embrace.

It will be Iľka because she is the one I have chosen.

68.

Iľka has no trace of Gizela's bitterness, none of her resentment: how has she managed that? She understands what I'm talking about even without knowing what it is. She must have realized at some point that she could become bitter but has chosen not to.

Any topic she comments on, she does so for the most part very level-headedly. Facebook, for example: she wonders why people share every detail of their private life. She can't understand that, she instinctively senses how sick it is to broadcast that you're pregnant, or post a picture of yourself straight after giving birth.

Down in the village those sorts of things weren't trumpeted about, everyone just knew.

It's the absence of privacy that bothers her. Her grandfather simply knew that she was pregnant, and when she asked him how he figured it out, he said he saw it in her eyes. When a neighbour asked if she had collided with a cart shaft, she had no idea what he meant. Privacy village style. Euphemisms are used sparingly in Šumiac.

One of her grandmothers was known as Sliepka, or Blind Hen.

I think it was Iľka's paternal grandmother, whose cousin, showing off with a whip, slashed her across the face when she was little. She lost the use of one eye and their parents agreed that the boy would have to marry her, for *who would want the girl now?* In the end he didn't have to, someone else came along.

Her maternal grandmother was known as Terina, meaning the daughter of Terézia. Yet another 'grandmother' was Čírička, because as a child she kept saying *čírik*, a diminutive of *čír*, the local version of a dish made of flour and potatoes. She was a hungry child and the nickname stuck for life. Some of these grandmothers must have been great-grandmothers or step-grandmothers.

All of this could be coming straight from that debut of Klára Jarunková's, the book that is nowhere to be found. Maybe that's precisely the reason Iľka remembers it.

She remembers all the names and nicknames. Even though Jarunková appeared in her book as Katarína rather than Klára. As a young girl, Iľka attended the young author's reading in the village and asked her:

The Katka in the book, is that you?

69.

The psychologist rings, her voice sounds unexpectedly stern and authoritative. Now I really can't form a mental picture of her. Her voice has overridden any previous image I had formed of her. A psychologist from Orava who has adopted the Upper Hron valley: this is not a voice I can imagine getting into folk dress in Šumiac as the two of them set out for church first thing in the morning after Iľka's husband has fired up the stove, to join the locals whispering *kristos voskres*, the Easter prayer, the psychologist wrapped in a woollen shawl and wearing a bonnet with a baršon over it. But we are getting close to Christmas now, there are Christmas pastries in Iľka's kitchen, which I know she has baked specially for me.

Outside the world has turned white, just as on my first visit. I imagine what the village will be like as the women begin to trickle into church in their folk costumes, walking up the road in the silence, not that the place isn't silent anyway.

Now I really feel as if I were coming home.

It's winter again and I have witnessed every season here, every kind of weather. I take off my trousers and Iľka hands me one of her skirts, I pull it over my tights, a pleated skirt made of pyjama fabric, blue stripes, no clips or buttons, I wrap it around my waist, tie the band and take a few steps to and fro.

She tells me to go and look at myself in the mirror, there's one by the window in the sitting room. I recognize the fifties fittings, Gizela had the exact same mirror in Bystrica, the same veneered furniture, a mirror on a small open cupboard with sliding glass doors, I know exactly what my grandfather used to keep in there, I remember the musty smell of the objects in it, the boredom and the dusk of a Sunday afternoon sprawled across the carpet.

This mirror, too, is tilted forward, it's been about to fall off the wall for years.

The skirt makes my hips look wider and my waist narrower, its below-the-knees length makes me look a little taller. Being wrapped in 4 metres of tightly pleated fabric changes my gait, the only person still making skirts like these is the *woman from Helpa*, the skirt moves as if it had a life of its own, stiff yet bouncy at the same time. I'm also wearing an apron on top of it, the movement takes place under it.

The bottom hem is reinforced with dark-blue lining, my hips allow themselves be seduced by this movement, I feel it has immediately given me something of the gait of these women, the village women.

If I lived in Šumiac, I might even wear it, like now, with a jumper, cardigan and T-shirt like Iľka, with thick or thin tights, bare-legged only in July–August.

An item of clothing that one can wear all one's life and that adjusts to any figure, generation after generation. It wouldn't feel weird to wear it, though only in three villages.

Elsewhere it would count as fancy dress.

70.

It's starting to make me anxious. All those rules about what you are and what you are not supposed to do at Christmas. The whole panoply of customs and superstitions. Who may put what on the table, what you eat and where.

Iľka turns on the radio: folk music is playing and she checks that I don't mind. I'm pleased that she has sensed that a woman who has been coming to her to learn how to make a bonnet is not necessarily thrilled by everything to do with folk art. We listen to the music and stitch.

On Christmas Eve, if you let a strange woman into your house, she will bring misfortune, beware of strange women in the house. If you sneeze in the morning before breakfast, you'll live a long life. You mustn't leave laundry hanging out to dry, or the person whose clothes are on the line is sure to die soon. If you're missing something, avoid borrowing it as that brings bad luck. Though I'm sure there is a whole load of stuff that brings bad luck simply by its absence.

Abiding by all these customs is stressful enough even without all the rules about eating and drinking.

You mustn't shout or sneeze at someone, or death will find them, though sneezing after breakfast rather than before betokens a cold, not a long life. Animals well looked after on Christmas Eve will start speaking the humans' language after midnight. You can check for yourself by going to the cowshed. Mind you, anyone in the village who doesn't go to midnight mass is regarded as untrustworthy.

Customs are necessary so that they can be applied retrospectively, to supply an explanation for old injustices or unexpected events, by providing a missing cause.

That's when we're suddenly reminded of that sneeze, that fateful tripping over a table leg, or that we're out of salt.

Now that we know that women didn't go to the cinema to make sure they didn't give birth to ugly children, I wonder what it might have been like to live with such beliefs trapped in a communal household with four families—twelve souls? Christmas dinner consisted of a dried mushroom soup thickened with roux and poppy-seed doughnuts. Followed by poppy-seed strudel. That was it. In Šumiac, that is. I wonder what happens in Pohorelá, where people do a lot of cooking and a lot of eating, according to Iľka's daughter-in-law. And since she says so, I must note it down.

Christmas customs lull us to sleep. I don't even notice when we stopped talking but I see that Iľka is tired, she has palpitations again, she is short of breath, and I've had enough too, I need some fresh air even if it's minus 10 outside. This shift is over, I start saying my goodbyes, hand back the skirt, ask Iľka how she's feeling, and that's when she says that sometimes she feels as if something was pushing her down into the ground.

Sometimes she feels as if something was pushing her down into the ground.

We're about to leave and she makes me take all the leftover doughnuts, we pack up and she insists on walking me to the stop. I lead the way and when we reach her narrow gate I try to swap places with her, so that I can see her walking ahead of me and perhaps hold her arm, but she doesn't let me. I go through the gate and as I turn around, I see her lying on the ground. She has slipped on a patch of ice, without making a sound. I couldn't catch her.

It happened so quickly, and now the scene will replay in my head over and over.

If the lady of the house falls in her doorway at Advent, it means there will be misfortune.

Now I understand everything.

I wait by her door, terrified that this fall will be fatal, as is so often the case with older people. That she might never recover. We ring her son who comes and carries her back into the house, and Iľka says I should go. After that I kept in touch by phone whenever I could.

Only the following morning did I learn that she was admitted to hospital with a broken ankle and needed surgery. The psychologist with the stern voice became a vital go-between, a faceless stranger. She was happy to play the role.

I headed back to Bratislava but remember barely anything about the journey.

This is all wrong, I can't rely even on my own observational skills, having long ago lost any illusions I may have had regarding my memory. What is it that I want so much? Why did I expend all this energy, taking the bus to Šumiac once a month to visit this kindly woman who is now fighting for her life, who has to pull herself up by her own bootstraps once again because I wasn't there to catch her at the crucial moment.

A Christmas present. From Katarína, the woman who has been coming to her because of a bonnet, thinking that the jigsaw puzzle would come together in the end. I have no right, no right either to the book or to the bonnet. I have failed this woman.

71.

After you turn 70, every year is a gift, Gizela used to say. Or some-times an unwanted bonus, actually.

The psychologist later gave me Iľka's mobile number, which I never needed before, and from then on we were in touch, at least by phone. Iľka would be spending Christmas in hospital with a broken ankle, aware that at her age everything that happens might be for the last time.

All through Christmas I keep thinking, she's got to live to her eightieth. I'm willing her to pull through. She doesn't complain, but she's in shock, I can hear that in her voice.

I can't stitch, I can't write, I can't even read.

All in all, this Christmas is jinxed, everything that could possibly go wrong does, against the jangling backdrop of the unceasing pangs of my conscience: the frightened look on Iľka's face after the fall—her skirts mitigated the blow, and the bonnet reinforced with cardboard once again acted rather like a crash helmet. A fracture of some other kind could have been far more serious.

They discharged her after Christmas Eve because the hospital was short of beds and reaching her by phone was difficult as she couldn't hobble all the way to the landline and the mobile coverage in her house was patchy.

Brief conversations, with her words cutting out, Iľka trying to convince me not to beat myself up, that it wasn't my fault. But I was with her when she fell and that means that I failed to look after her properly.

72.

The bonnet is abandoned for the moment, I might never finish it. First I have to see how Iľka really is. If she still feels that something is pushing her down into the ground.

We won't do any stitching.

Even so, this visit feels like an act of cleansing. I've left everything behind down in Červená Skala where we change from train to bus, it smells like hell, like hell's kitchen, that's what my daughter said about the train journey. There's nothing further up, we are finally here after the long Christmas holidays, let's wash off all the darkness.

We'll see what happens.

I'm trying to remember if I had any inkling when I saw Gizela for the last time that I would never see her again, but no luck. Though there's something that I learnt from her passing: that look

KATARÍNA KUCBELOVÁ

in the eyes of someone about to die. I saw the same look in her husband's eyes years ago. But I only realized this when those eyes dimmed for ever.

But Iľka will recover.

I don't see that look in her eyes, although her appearance has changed radically: instead of a skirt she has put on trousers and a jumper, she's not even wearing her bonnet, I've never seen her without a bonnet before, apart from the time when she showed me how she ties her topknot to make it fit under it. And now this girlish hairstyle, the freshly washed hair in a loose ponytail. She looks healthier, younger, better groomed. She's pulled through.

I never imagined that she would celebrate her eightieth birthday without a bonnet.

I thought she'd put on her best bonnet, the one she wore when she was expecting us last summer. But these birthday celebrations have been going on for days now, she's had a stream of visitors ever since she has come home from hospital in the middle of the Christmas holidays and everything froze into a single blob of lead: Christmas, the end of the Old Year, the start of the New, Iľka's absence at Christmas Eve. And her round birthday.

The psychologist is here with her husband, Iľka and her daughter-in-law, me and my daughter, she is the one who rounds out this heterogeneous company.

The psychologist. We meet at last. If she weren't vegetarian, would Ilka have thought of mentioning her during one of my visits? Would I have had reason to write all this down? Had the psychologist not written about Ilka in her book, would I have picked up on her story? And had Ilka not suggested that we both come at the same time to spare *her daughter-in-law having to do a spread twice*, would we ever have met?

She could be Ilka's daughter, a similar type, straight hair simply tied back, very casually dressed, someone used to not drawing attention to herself, subdued colours, delicate patterns on a delicate frame, her appearance taking the edge off her stern tone, which I expected to crow about her 30-year-old friendship with Ilka, take credit for providing solace, perhaps even for saving her, I expected her to bring up some of this, perhaps some story from 20 years back. But no, she does none of that. So this is the psychologist, observing, smiling, attentive to my daughter, not letting her noisy husband distract her.

As soon as she leaves the kitchen for a moment, Ilka tells me that something good has come out of this after all: it has brought her and her daughter-in-law closer together after many years, she's been looking after her conscientiously and could see how many people come to see Ilka, her incredible network of friends and acquaintances, the future stuff of legend for her daughter-in-law.

And when everyone has gone, Ilka and I share a quick hug and I notice that the psychologist has spotted us through the window: if ever we all meet properly, it should be interesting. And then Ilka heaves one of those sighs that usually end in laughter.

There's no mention of embroidering, and Iľka is not wearing a bonnet.

Everything could take a different turn now, but how is she going to complete all those commissions? Everything has come to a standstill, her work and mine, we are waiting to see how it all pans out.

We are dealing with material that is far more delicate.

I haven't yet acquired the skills and instincts needed to handle it.

I'm still learning, aware of how awkward and inflexible, how useless and superfluous I am.

Iľka, the always generous, the one who repeatedly assures me that I shouldn't blame myself. So that's how our bonnet embroidery project comes to an end, I no longer even care whether I'll ever finish it, it doesn't matter. We're alive and she has lived to be 80.

Iľka, so frail in every respect, so unlike her sister, who had much more stamina and did everything right, yet passed on long ago.

We go back to her house to say goodbye. I try to keep it as brief as possible, Iľka is more exhausted than I've ever seen her, immediately loses herself in the past, the present now totally on hold, her mind overwhelmingly dominated by the time her body was still at full stretch and her head could keep up with it all, the present not offering her anything to latch on to. I listen to her talking, I've heard all her stories before, once or twice, perhaps even three times.

And this is the point when I feel the full impact of the isolated nature of this place, it could drive you crazy: you have to be very active here, or take to drink, drink yourself systematically to death. Or perhaps not. Either way, if I could just get to the end of this deserted street and get home, sit by the stove, doing something, anything, stitching a bonnet, doing anything with a goal, that keeps me occupied, and produces a result that is immediate and tangible.

I am lucky I can go back to Bratislava. I will never be able to imagine what it feels like to have no chance to escape, what it means to be stuck here for months, to have to travel to Brezno, Poprad or Revúca to do the shopping, see the authorities or the doctors, to live here without a way out, to live here with them.

73.

The bus is already waiting at the stop, no one but us around, so we get on; we can't stay outdoors anyway as it's freezing and there's a howling gale blowing. It's just gone dark, there's no one about, the village is deserted.

Where has that woman gone? She must have boarded the bus along with us but now she is nowhere to be seen, it's just the driver and two boys, around 10 years old, my daughter and me. We sit in front like passengers in a car, close to the driver. No Roma today. It's the weekend.

He asks me questions, I answer. We are the only passengers and he is surprised to learn that we're from the capital. I don't like Bratislava, he counters. He could have kept this to himself but apparently felt compelled to say it, it's normal to speak your mind around here. I change the subject and say how much I enjoy coming here, and so on. Have I thought of settling down here? Not a question I was expecting. Nor this one:

What does your husband do?

He wasn't concerned about whether I had a husband or not, that had already come up: what he was interested in was his profession. As to where I worked, that didn't occur to him to ask.

Right, then, my turn to ask him a question.

Of the children in the bus, one is his son, the other his friend. His son has no one to look after him, so he rides the bus with him up and down Route 66. His other son is with his sister in Čierny Balog, they live somewhere near Brezno. They used to have three houses, the boy adds, but now they have only one.

I don't ask any more questions as I would have to ask him about something very specific first.

But I can't in front of this boy, even though his father would talk, he would tell me everything before someone else got on the bus or before we got off.

We get off and I hope that his wife didn't die.

That she has gone to Austria to care for a pensioner and will be back in two weeks.

74.

Later Ilka tells me that during the weeks she was ill she wasn't even able to read the clock.

She just wasn't taking anything in. We'll never know how many visitors she had, or work out how long it all lasted. She is unable to say anything about that winter, she has no memory of it.

I am back after a break of three months, the longest we've had. But this is definitely her: she's her old self again, the person I need her to be, the bonnet is back on her head, she is walking without crutches, it's spring. She can make it as far as the nearest shop, though not as far as the church.

The reasons for her isolation were surprising. There is mobile coverage only in certain parts of her house and she wasn't able to walk all the way to the room with the landline. She had to rely on her son and daughter-in-law whose lifestyle is not as open as hers.

I don't know how to describe it, she says, but associations do come. We mustn't ever think of ending it all. We have to think of our loved ones, as they would be left carrying the burden for the

rest of their lives. For instance, when a doctor asks you about the cause of your parents' death.

So you tell them. My father hanged himself.

She didn't mean this as a comparison, it was just something she remembered.

Svetlana Aleksievich says that we—she means *homo sovieti-cus*—are used to enduring until the very end. This is true of Iľka but what if it was also true of her father, what if he actually held out to his end, an end that was like any other, something normal and unavoidable?

She recounts again the story of her father's suicide. He was good with his hands. They were, she corrects herself, reverting to the third-person plural. He had a piece of advice for everyone. They had. But not for himself. For themselves. Three years without a tear, then seven years in tears.

Every now and then, however, I glean some new fact: it's not just the context that helps me to rejig the events of her life in the order of their importance.

Her father was an orphan, one of several children. Orphaned at the age of nine, that is, in 1918. Her father was an orphan—I find it hard to write this down without retrospectively using the third-person plural. They only went to school in winter, couldn't read or write. Until he was drafted into the army and everyone who couldn't read was told to raise their hand.

Many young men were ashamed to raise their hand but her father did and was taught to read and write.

After that he learnt to do everything else as well. He worked in the forest. He could have done any job, because he was good with his hands, but he just wanted to work in the forest.

When she was young, she and the other children slept on straw mattresses on cots that were kept under their parents' bed. They would slide them out at night, and early in the morning, after their parents had got up and gone to tend to the animals and prepare food, they would slide the cots back under the bed and slip into their parents' bed, under the eiderdown and go back to sleep. That's the romantic bit.

Less photogenic, later, was having to do the cooking separately but on the same stove, separate pots and pans and the hierarchy involved in the preparation of food. And the other details that shape one's life: the ever-hungry newborn, not enough milk and the baby's green stools, having to cope with sleeping in the pantry behind a screen, which made access to the stove impossible, too many people in the same room, a hotplate beside the bed. A mother at 20, these days she'd be regarded as a child, caring for an undernourished infant, born in a hospital to boot, she should be ashamed of herself.

The child survived. But only because she summoned every bit of her strength.

So this was Iľka's winter, the winter after her fall, having to forgo Christmas and accept anything and everything that happened, and when the time comes, allow her body be pressed into the ground and be tipped over to the other side, joining the dead whose voices grow ever louder, ever more aggressive in assaulting the mind of this old woman with her declining strength. As night draws on and she finishes her long monologue, I see that her lower lip is quivering, I decide to leave and let her go to bed.

75.

Our Emilko is also out of circulation.

Says the waitress as she welcomes a young man, a regular.

We are in the snack bar at the railway station in Brezno, she's old enough to be his mother, while on the telly Antonio Banderas is hitting on a blonde by speaking Russian, he could be her father. The film is from the nineties, as is the snack bar.

They had to sew back one of his fingers, and half of another, the waitress continues.

Dasvidania, and onto a bus bound for Šumiac, all the way to the end, past the ridge of the Low Tatras. As we pass the Upper

Hron villages, the Roma get off one by one, fancy some hazelnuts, mister?

I will have to trek uphill all the way from Červená Skala, as there are no proper connections between trains and buses, the trains haven't changed in 50 years, no trace of the new double-decker trains like the suburban ones around Bratislava. This is a different country, a different state. It's a 3-kilometre hike uphill from the station.

On foot.

Walking along the ridge. On the next train too it's also mainly Roma, only three White people, the flowerpot with a metre-tall snake plant is probably theirs. Plus one wretched woman, crazed desperation in her eyes. And after Helpa, only me.

Civilization ends at Helpa. I get off at Červená Skala, see hardly any cars on the road, it's a beautiful day, the grass hasn't been mown so far this year.

I am offered only one lift, by a motorbike, a dark-green balaclava under a black crash helmet.

Headed uphill? Yes, thanks, but I'll walk.

I'll go uphill, right up to the summit, to the ridge, if the mountain lets me scale it, I'll climb all the way up Kráľova Hoľa, up to 2,000 metres on my own. I'll have to manage.

The motorbike bowls along on the new road surface, it's really not that far. The school has been weatherproofed and redecorated, and the municipal building where the shop is located is also getting a makeover. I'm always surprised by how much has happened in the village. The old pub has been demolished.

So has the House of Horrors in Brezno.

That showcase of the Romas' inability to adapt to their surroundings, the windowless building where they continued to live, gathering in large groups for a smoke on balconies without railings, a building right in the middle of this beautiful countryside, allegedly contaminating the entire area, including a house that Jano from Hronec decided not to buy years ago, still under socialism, even though it could have been bought for almost nothing.

Those living in the House of Horrors were relocated before it was demolished, meaning some 170 residents when it was at peak occupancy, plus 15 dogs all told, kept on balconies, in cellars and inside the flats, dogs that regularly attacked people. The rubbish thrown out of the windows used to be scattered by foxes and other animals everywhere. The negative image the building presented was at odds with plans to develop tourism in the Upper Hron valley, that was the official justification for the development.

A house of horrors, not of deprivation, of misfortune, of uprootedness—the Roma induce fear, sometimes even terror and panic. According to a television report, the house was *straight out*

of a horror movie, and the sentence continued with the euphemistic: *shortly afterwards, a mechanical digger sank its teeth into it*. In the same sentence. Like someone biting into a gingerbread house.

The locals refused to speak on camera, finally one came forward and said: *it's a gift from God.*

76.

The woman in the shop asks if anyone gave me a lift, people readily do around here.

I didn't want one.

Have I been here before?

I look familiar.

Ah, now it clicks: I'm the one who's been coming to auntie Ilka to learn about bonnet making. Then she plucks up the courage to tell me that I remind her of her daughter.

I glance at one of the photos on the wall. I'm just curious, as I happened not to look that way before. She at once wells up. I know who's on the photo. It's the local girl who died a year ago. One of her daughters.

She's been meaning to mention it. She once saw me pass by her house and thought I was her.

The house where I saw the woman in a black bonnet. When could it have been? Her daughter must have been dead by then. I go over to the counter and give her a hug.

I'm the girl who is alive.

I haven't died. I'm not her daughter.

Iľka is alive, too, she is fine, she's her old self again.

Later, when I mentioned this to Iľka, she said she'd known about this for a long time, even before her fall, but I suppose she didn't want to be the one to tell me, she left it to the two of us to sort out, rather than intrude in an unseemly way. She gauged the sensitivity of the situation correctly.

Or she just forgot.

Then she added that I ought to drop in whenever I pass the shop.

I couldn't think of anything to say to that woman by way of consolation.

But you do live here with us.

77.

I must go up the hill. Higher and higher, whenever the weather is decent, reach at least the Predné Sedlo pass, going first towards Úboč through the woods, then up the rocky path to the meadow, it will be dark in three hours, then through the forest to Skalička and another wood all the way up to the pass. I don't meet a soul, something is drawing me uphill, even though night is about to fall. I'm the girl who is alive, I have to be on the move, moving upwards.

A neighbour of Iľka's said she would join me at the top and we would go down together. I'm waiting in the shelter in the pass as the day is ending and the sun is slowly going down, and I'd like to stay until it gets dark, ideally keep going up but I can't, I have to get back in daylight. The neighbour eventually shows up, a 50-ish woman with an Alsatian.

We've not spoken before. If I think about it, when we met in the village street and I asked her if she'd join me, she didn't hesitate at all, but finished what she was doing, got changed, and set off after me.

She is a kindergarten teacher, I didn't know that, her daughter in Bratislava is about to get married. She may lose her job in September, as three teachers are too many, beyond the means of the municipality. If I understood her right, there are no White children in the kindergarten although the number of Roma

children is not going up either. Not many of them attend kindergarten, as their parents can't afford lunch and in winter it's hard for them to make the 15-minute trek up the hill from the settlement to be at the kindergarten by eight: they first have to light the stove in their shack, especially those in the second row of portacabins further away from the road.

I don't know if I would be able to cope; probably not. Iľka would say that when she had young children and had to be at the shop by six, she first had to deposit her son at her parents' at the far end of the village, see to the cows, and then, of course, there were the quotas to deliver.

The quotas.

This wasn't a problem for Iľka, she was able to cope with all the hardship of such an existence, not everyone ended up burning out, drinking themselves to death or hanging themselves. Only some did.

Now the older generation expect the Roma to cope just like they did. Hard as it may be, they have to go through the same things they themselves went through. *It's only fair.*

Sometimes children come to the kindergarten and say they were cold at night.

78.

I still haven't finished all my embroidering though the front, where some of the underlay is meant to be visible, is done now, Iľka offers neither praise nor criticism: it's fine. We start looking for any threads that are still missing, she gives me more than I need for now, enough for the next bonnet.

I still find it hard to believe that she's back in shape, her gait as sprightly as before, she has to remind herself to slow down, because if she walks too fast it will catch up with her and her legs will ache. The worst thing is being dependent on someone to help, her daughter-in-law in her case.

We no longer do any needlework, we just talk, I can finish my stitching at home and then we shall assemble the bonnet together. I'll need her help with that. Iľka has many new commissions, she is finally back at work, halfway through a shirt for a male folk costume and an apron for a woman's dress and there is wool waiting to be turned into wrist warmers. A white festive baršon is spread on the table.

I've heard all her stories before, occasionally there is something new, something new surfaces and I can add it to the picture, like the thing about the quotas, the ruthlessness of the communists.

Voluntarily by force.

Instead of making people hand over their quotas, the state bought the produce at a symbolic price, a system that was carefully

thought through, down to the smallest detail, to avoid giving the impression that the communists were doing anything by force. It was like feudal tithes: eggs were candled and weighed, if you didn't hand over the requisite weight of beef, you had to buy it up for several times the price the state paid, otherwise you could land in prison, groceries were rationed, there was a thriving black market despite the threat of imprisonment. That's what it was like in the fifties and in this neck of the woods, right into the sixties. But it was all on a voluntary basis of course, sold of one's own free will, in the same way as, in the end, people 'freely' handed over their property to the collective farm.

79.

The difference between us is one of perspective. I'm simply making a bonnet, while Iľka believes that I'm making it for myself, that we're returning to the past, to the time when every woman had to make her own folk costume. And embroider her own bonnet, out of necessity, as without it she couldn't appear in public. Now it's second nature to her. A woman had at least to have a go at making her own. Perhaps the nuns could have given it a try back when they were living at Červená Skala and the market stretched all the way from the station to the turn-off for Muráň.

The way I see it, I'm just embroidering a bonnet, not for me to wear.

I'm letting the bonnet guide me.

It serves a completely different purpose, I won't wear it, neither in a show nor at a wedding.

I show her the colours I've chosen for the main section at the front, the predník, subdued and not garish, of course, soft, muted pinks, not the kind used these days, but that's fine, we compromise and I adjust my plan to do half the florals in a dazzling orange but nonetheless after an authentic old pattern, at least that's reassuring.

Iľka shows me a baršon about a hundred years old, superb quality burgundy velvet with elegant embroidery, quite minimalistic by Šumiac standards. This one was made by a nun.

It has to be finished off now, a hundred years later.

The customer has been waiting for a long time for Iľka to regain her strength and work on it.

The stitching is finely worked. Alas the owner wants some of those shiny beads sewn on. The thread, too, is very good quality, all silk, no cheap synthetic stuff.

80.

Seeing how the death of that young woman terrified me seems to have terrified her. She senses that someone who is rootless can easily slip their moorings. This is not something I can judge, as it hits a little too close to home.

We can all have different faiths, or have no faith at all, this is not a subject she brings up very much, but she does so now because I've been asking too many questions. I don't know what message this must have sent her.

She shows me a prayer she once heard in church and tells me to choose from it anything I like.

Sometimes a single sentence can be enough.

I'll give it a try. It begins with a plea for forgiveness, flowing naturally into forgiveness to one's ancestors for the sins that have left a mark on mind, spirit and body. Of the person who is making the plea. Beseeching forgiveness for those family members, both living and dead, who have inflicted harm on us. A prayer designed for our private family hells.

But that is not the end of it, the supplicant also begs forgiveness on behalf of everyone whose flaws have given rise to the problems of the present day.

And then—it keeps spiralling—the word *liberate* crops up in the prayer. At this point the living and the dead are treated alike,

they should all be liberated of the shackles that bind. This seems quite extraordinary for a Catholic prayer that is supposed, primarily, to concern family and relationships—how does a longing for freedom fit into this context?

The supplicant is also supposed to beg for any negative consequences not to be passed down to future generations.

A prayer for familial love and, at the same time, for breaking free of the family. For the health of the soul that the prayer is meant to bring.

To ensure that the believer doesn't go crazy. Truly something for freethinkers, despite being embedded in Christian imagery and conventions familiar to me, stuff that has to be stripped away, being just as ridiculous as Rompop or Pop Idol.

Guardian angels camped around the hearth and the home, shackles and the cleansing blood of Jesus, the Cross of Jesus hovering above the head of every single member of the family. Considering the length of this prayer, it could do with even more imagery.

I forget if I said this to her before or after, all I know is that I said it in a whisper, I don't know why, but anyway, it ended up sounding quite melodramatic. I told her that I'm incapable of forgiveness, it's just something I can't do, I accepted that a long time ago. Not even Gizela: I've never quite forgiven her for dying the way she did. I wonder if Gizela forgave me for not being by her side at the very end. We don't probe this any further, but focus on the bonnet, that is certainly one way.

To keep going, all the way to the end. Finish the bonnet, every single one. Even if a hundred years later.

81.

I'm not sure if it's a good idea: the weather is unpredictable, it's sunny now but the peak of the mountain is under a cloud, but I must go and so I set off, I shall get as high as I can. I've never made it all the way to the very top, the weather is holding for now, I'm not sure the mountain will let me scale it, I enjoy using the mountaineering lingo even though this mountain is not quite 2,000 metres high, but I want to give it my all, I want to focus on every step I take, I'm the girl who is alive, while so many in my family are dead, without a cross above their heads, without angels camped around them. So I put one foot after the next, it's still sunny and when I reach the first suitable spot from where the transmission tower should be visible, I can indeed see it as the clouds have begun to break up, it feels great to be going up, by the time I get to the top the weather has improved, though there are still a few clouds around, it's pleasantly cool and the view is great.

I've made it.

I change my wet T-shirt for a dry one and set off on the descent, and as I turn around, there are two figures standing where I've just been.

I'm the girl who is alive. The only one of the three, in fact.

As I was leaving Iľka's house, a Roma woman told us that the body of a young Roma girl was being brought over today for a funeral from somewhere along the Váh valley, where she'd worked and maybe also lived. She was 28, single, no family or children.

She had thrombosis, which doesn't fit the stereotype.

When you reach the summit, you can connect with everything down below, maybe that's why I didn't stay up there for very long.

And for me, right down below, at the very bottom, is my mother, not Gizela but Gizela's daughter, my sister. When Iľka speaks of her dead mother, it's as if she were still with us. When I speak of my mother, it's as if she were no longer with us. But the gap between the two is too much to bridge. There was a time when I wanted to keep the rest of my life secret from her. Behind a closed door. No Fourth Commandment. Except that sometimes I'm surprised to be alive. Or rather, surprised at being surprised.

And what does Iľka make of this? A dying person is someone who is waiting. There is a house in the village, the oldest one, the only one that didn't burn down in the big fire at the beginning of this century. It even has a date on the trager. Iľka checks if I know what a trager is, I'm guessing it's a beam or joist of some kind. An old woman used to live in the house, she had a daughter who had moved to Jáchymov and the woman lay dying for a long time, leaving the entrance door ajar. She just lay in her bed, by the end

only listening to the voices that passed by. She must have been in a lot of pain, as Iľka says she kept pressing her hands on her chest and tugging at her oplecko, her embroidered shirt, for people lived and died in folk costume.

And when she heard her daughter's voice, she died.

This is the ending to the story that fills me with dread, I won't go and look at that oldest house, which I'm sure is still standing.

At least this is how the story has gone down in local lore. The actual moment of death isn't the point. Only the woman who died can know about that.

Except that Gizela, as I've mentioned before, didn't wait for anyone. At least, no one that I know of.

I descend the hill, more slowly than when going up. I'm being careful, I suppose I'm halfway down when I notice I've missed a call from Iľka, I should have been back by now, she is worried, I'm nothing but trouble for her.

I go straight to her place, she doesn't reproach me, just says that I gave her a fright, that she was concerned about me. Now she is even more convinced that she has to look after me, that embroidering by itself is not enough.

82.

The most interesting thing about prayers is their subject matter.

Apart from their imagery, of course.

Where did Gizela find that prayer for a rapid and peaceful death? Was it in one of her brochures, that prayer to St Joseph, the patron saint of the dying? Did she look for this specific one, or did she chance upon it? Did she realize that none of us would be able to look after her the way she'd looked after her husband? Were we meant to appreciate that the prayer was an indication that she didn't trust us? We have always assumed that it was the final act of her lifelong self-sufficiency, of being able to look after herself whatever the circumstances. When I found those brochures, in the place I last saw her, one fell open at the prayer to St Joseph because that was where it had been most often opened, but perhaps only there, the fear of dying preventing her from going any further.

And as she died on St Joseph's Day, I wonder how many times she had read these sentences before that day arrived? For us it came unexpectedly, out of the blue, on 19 March, St Joseph's Day, in hospital, so none of us had to do anything for her.

Ilka used to pray to help her cope with her forced marriage to a man from the neighbouring farm, three houses down or up the street.

In later years she prayed for help to forgive her entire family, both for her own mental health, and that of her children.

And one day perhaps she will pray for a peaceful death.

Meanwhile, she'll keep embroidering, right to the end, as long as she can.

And when she no longer can, she will let it go.

Someone else will finish it. Perhaps a hundred years later.

83.

In my favourite shop with the stove I am served by the same pretty young assistant as always. She has a shapely figure and long hair, whenever I see her I wonder if she's 18 yet, given that she has to stand there enduring sexual innuendoes from men in overalls, *You look good enough to eat*, and the like. She doesn't respond and only lowers her eyes.

It's holiday season, the village is packed, the holiday cottage owners have returned, there are even children playing in gardens by the lime-plastered boxy houses. Three young girls in the shop line up against a cardboard advert for Gemer beer leaning against the stove, the salesgirl is the tallest, with only the bottle top visible above her head, Sofinka and Lea only come up to about the label.

A pensioner is buying two miniature bottles of borovička, 50 cents each, and puts one in each pocket of his overalls.

An elderly woman is buying Becherovka. They only have one-litre bottles but that doesn't bother her.

My daughter and I take a walk around the village; as we count up to 100, we come across Romeo who is on his way to his evening shift at the collective farm. *Louder*, he tells us. Soon we pass a gorgeous Roma girl, she's 13 or perhaps even 16, she's bound to bump into Romeo sooner or later.

Will he try to chat her up as well?

Iľka is happy to see my daughter, once again she is the centre of attention. She finds a nesting doll somewhere, calling it by a Russian name, marusia.

We hang up the laundry; the village radio is playing. It announces that there will be no running water in Červená Skala all day, and the broadcast ends with a song about *my beautiful motherland*.

When we have a moment alone, Iľka asks how I've been and I tell her that my last visit really helped, the hike up the hill.

Eventually my husband arrives as well, straight from Kráľova Hoľa, finally he's here, I'm not a widow or a prespanka, he really does exist, this is concrete proof.

As we are about to leave, Jano from Hronec turns up with some 20 litres of žinčica in plastic bottles on the back seat, he is even larger than last time and presses a valaška into my hand. It is

delicately inlaid, it's hard to believe that, of all people, a man with hands this huge, can make something like this. The wooden shaft is inlaid with wafer-thin metal sheets worked into delicate patterns, it's a real hatchet, it feels good to hold.

My husband asked how old I thought was the child in the pram we passed, its Roma mother was feeding it salty crisps, straight from the shiny packet. A year, 18 months?

Roma lined the entire length of the road with buckets of blueberries and cranberries, there seems to be a really good crop this year and they have brought it into the village. One stops in front of us, a man of around 50 with his wife.

He carries a bucket overflowing with cranberries and tells us about the environmentalists who called the police, the policemen had laptops, and he nearly had a heart attack when they showed him his photo in the computer and fined him 50 euros. He didn't have the money so both he and his wife were formally charged with a misdemeanour and had their little rake confiscated, as it was illegal to use one, they had to empty their buckets and had all their fruit trampled on. What he was carrying now he picked by hand. It's quite beyond him: absolutely everyone goes berry picking.

Both you lot and us.

They have always picked berries, supplementing their income this way for years.

He tells us he lives here, just outside the settlement. He and his wife have four children, they wanted two girls and two boys, but ended up with three boys and a girl, these are now between 30 and 35, each with their own house and family. They are grandparents now and live alone.

The slum dwellers who live at the back are riffraff, but the Whites don't draw any distinction between them and the other Roma. The riffraff live in about 10 shacks, sometimes as many as 20 people in a single hut, that adds up to about half the settlement, but the man with the cranberries won't have anything to do with them.

There's a woman who lives in a shack near the forest who gives birth twice a year, she must have about 17 kids.

Then there are the upstarts, they hook up *on them mobiles*, he doesn't know much about it but they do everything *on them mobiles* these days, they come and see a girl and stay, the upstarts don't give a damn about anything, they just make a racket and stir up trouble.

The mayor doesn't care much about them either but he won't be in charge for much longer, *we'll elect Jarka, Jarka is wonderful*, she helps our people, she used to work at the community centre, everyone in the settlement will vote for Jarka because Jarka is so wonderful and so nice.

She never shows any of them the door.

The local elections are due soon but I can't find a single photo of Jarka on the internet, just something about a collection she organized for the priest in Šumiac whose wife is ill, as are all three of their children.

The priest who concludes every mass with a joke.

84.

I wonder if this Roma man has decided to sit next to me on the bus because he has worked out he'll have more room that way, because the man is wider than the seat, even though there was a seat in front of me that was free, next to his wife and son. I have no idea what they're talking about, I don't understand a word, the boy is about five, the wife is very quiet, she seems exhausted.

And what's all that yawning about?

An old man is getting off, he's White, and that's what he says to the Roma's wife in passing, addressing her informally, and her husband replies on her behalf, it's 'cause she's hungry, he says, it's meant to be a joke, the men share a laugh.

Stuff a bread roll in her mouth if she's hungry, that'll fill her up.

I watch the woman, she's about my age, give or take, her son is sitting next to her but she doesn't move a muscle, perhaps she's used to it, her husband mumbles something in agreement. This is Route 66, there are situations when the Whites get along with the Roma, the bus continues its journey, and the family gets off at the next stop, in Halny.

There is heavy machinery where the House of Horrors used to be, something new is growing. The crowds that boarded the bus at the Czechoslovak Army Street stop in Brezno have slowly drifted away, and, as always, by the time we get to my stop, the only ones left are those going to Telgárt, plus a young English-speaking man with a rucksack who asked for his ticket with the English word *one*, and the driver gave him two, one for him and one for me.

85.

We start with the houses across the street from Iľka. The owner of the boarding house where I'm staying is looking for workers, everyone is looking for staff, the shortage has never been as notice-able before, now there are ads on the radio, on billboards, a car manufacturer has even left leaflets on seats of the Route 66 bus. The owner of the boarding house needs seasonal workers for apple-

picking in Italy; he's been running the business for fifteen years and for the first time he is a hundred people short.

A car is parked on the empty plot. The Roma listen to what the man has to offer. The first thing they want to know is whether taking on seasonal work could mean losing their unemployment benefit.

One young Roma can't be bothered to get out of his car, he talks to us with his elbow sticking out of the window, smoking a cigarette.

A slightly older fellow, who makes a living from sharpening chainsaws, asks if we know who will be the next mayor. We try Jarka but he puts us right: we are actually talking to the next mayor, he's sure to get at least 250 votes. We ask for his phone number but he points to his house instead, we should write down the house number and find his landline in the phone directory. The prospective mayor has given up on mobiles, as he kept losing them.

One of the Roma is actually white: light skin, reddish hair, Roma features, he says nothing, just smiles.

An ever-growing crowd gathers around us inside the settlement. We are standing in front of a green two-storey house with a shop on the ground floor, I had no idea that the Roma have their own shop inside the settlement, though I must have passed it before.

Smiles all around, they wouldn't mind going, they would all go if they weren't worried about losing their benefits. The women would go too. Jarka's name comes up again.

I really must meet this Jarka, everyone goes weak at the knees when her name is mentioned. I enjoy seeing what it does to the local Roma. Jarka, a name I can't put a face to because there are no pictures on the internet, not even in the run-up to an election.

Women can go, too, says one, provided they are single. But there aren't any like that in our settlement.

The women in the crowd say they wouldn't mind going, but they have young children. The young children would also like to go and are disappointed to learn they will be allowed to go only once they are no longer children and, at the same time, they don't yet have any children of their own.

It is interesting to note the mutual lack of trust. One of the Roma women points out that there are many in the settlement with proper jobs, implicitly reproaching us for not being aware of the fact. I find myself surrounded by the next generation, they are good-looking and brash, one little girl thumps another for telling on her that she must repeat a year at school. There are so many of them, I can't keep up.

Auntie, be careful, he's got hepatitis.

The pitiful-looking little boy standing right next to me could be about five, six perhaps. I'm not sure if he's more yellow than the other kids, but he's certainly grubbier, he has a vacant expression. The girl just wanted to give me a scare and is now waiting to see how I react.

One final stop, right next door, is a brick house on the settlement's edge, no path or road, just trampled earth. A quiet Roma family, a pretty young woman and a taciturn man come outside, followed by two further women. The man works on a building site, they are rather busy right now, but he'll ask around.

It's gone dark, the settlement is still bustling, the village is deserted.

86.

It turns out that of course Iľka knows who owns the shop in the settlement, who their parents were, how they met, who their children are and who they married, just as who lives in the two houses across the road. She knows everyone, as if the dividing line had ceased to exist.

The families who live in the house behind the shop and in the two houses across the road are mixed, Whites and Roma. She knows everything, the settlement is diverse, there really are some Roma who are better off than she is.

I just can't understand Jarka, Iľka tells me, *how can she go around kissing those Gypsy kids. Every single one of them.*

87.

So once it's done, you'll never come again?

This is not the first time she has asked, she has raised this question before. Which part of the folk costume should we tackle next, making wrist warmers or macramé fringes for a baršon, sewing an apron, or maybe weave something? She knows I will come, I know it too, and that's why it's safe for me to say, no, I'll never come again, and she says, all right then, if you don't want to come, then don't.

In truth, I'm scared every time what state I might find her in, and I sense that we are both scared of the winter because last winter she fell over twice.

When I phone her, instead of saying hello she asks: *Are you here now?*

Assembling the bonnet is complicated.

Ilka irons the final embroidered section through a wet handkerchief, some colour from the pre-drawn pattern seeps through, staining the pink embroidery slightly blue, which I find upsetting.

Never mind, it won't be for sale, Ilka says. She couldn't allow it to happen with one of hers, but she is right, it's all the same in this case, what I wanted to know was whether I could do it. All along she was asking me why I really wanted to learn how to

make a bonnet, so now I also know that she understands the reason for the apparently self-indulgent urge to devote hours and hours of one's life to something out of sheer curiosity.

We start by sewing the lace onto the zadník, made of embroidered tulle, though this lace is no good, it's stretchy. Iľka repeats this every five or ten minutes.

But now it's finished and we can move on to the two front sections, which will be sewn onto the zadník and then we come to the final part, the chain.

It takes us a very long time to work out how to do it, and I start to wonder if Iľka is still up to it, she stays calm and keeps turning in her hand this way and that, over and over again. Every now and then she says something just to break the silence.

This is what you should be learning to do, instead of thieving.

She complains about the lace again, the one that's no good because it's stretchy. For the rest of the time, we are silent, except when she asks me to make her a cup of tea, or something like that now and then. We are sewing, by hand.

The youngsters, she says, do it quickly on a sewing machine. Another thing that has changed since I started visiting a year and a half ago is that other women have been coming to Iľka to learn from her, a TV reality show about folk art has sparked interest in folk costume among celebrities and hipsters, folklore is everywhere. *It's not going to die out.*

These things go in and out of fashion, in this case, about every 50 years. She has witnessed it only once, 50 years ago, in the sixties and seventies, when museums were springing up everywhere and both she and her mother donated to them the bonnets I later discovered in Brezno. How long will the current fad last? A year? Two?

These young women—as Iľka refers to the women she's teaching—are all 70 or under. A few days ago a young woman came to see her from Banská Bystrica, she's married to a man from Bardejov.

This is what you should be learning to do, instead of thieving.

I am worried that I might be exhausting her. We agree that I will stop by first thing next morning, before I leave, and we'll do as much as we can. Then I can put the finishing touches to it at home.

The bonnet will be finished.

Iľka attaches the zadník to the bonnet, to my bonnet which I still find hard to consider my own, the nearer it is to completion, the further removed it is, losing any connection to me.

I have mastered the bonnet and I'll be able to finish it at home without her help.

Now I must hurry to catch my bus. She will have a lie down and rest.

The end tends to come quickly.

Epilogue

Every time you go past that shop, Iľka has instructed me, you should drop in for a cup of coffee, and I do.

When I arrive, I learn that Jarka has won.

Because she had the highest number of votes, as the woman in the shop told me.

Most of them from the settlement. Some locals didn't want to vote for her because the Gypsies did.

I will remember the name Jarka the way the Roma said it, with all the emotion they imbued it with.

Later that day I spot her by the spring where the consecration of the water is held: huge crowds, Epiphany. She is in folk costume, with a pink baršon, a few other women are also wearing folk costume, and Iľka points out to me those items that are her work. Around the spring, on the ground, an assortment of small watering cans, jugs and plastic containers filled with water.

That's a Gypsy dog, the voices of the women at the assembly mingle with the priest's monotone. A group of Roma are elbowing their way into the group from the right.

My fingers are frozen even though I'm wearing gloves, so Iľka warms my hands under her armpits, she has wrapped herself in a blanket rather than putting on a coat. It dawns on me that the folk costume doesn't come in a winter version, and some women

are wearing just an oplecko, the embroidered short-sleeved shirt, with a woollen blanket thrown over it. It's not really cold, of course, just a few degrees below, but in the old days, I am told, the frost was so severe that their arms almost fell off. A fierce wind, 10 degrees, maybe even 20. In Šumiac. they don't add 'minus' or 'below'.

As we head back an old man asks Iľka if she's covered herself because she's ashamed that she lives at the lower end. Local humour, the lower end of the village is adjacent to the settlement, and Iľka points to the fence with missing—stolen—wooden slats around an abandoned house. *Gypsies.*

It turns out she was wrong when she said that no Roma would be interested in seasonal work in Italy: about ten people from Šumiac went, some hundred altogether, including folk from the Muráň plain. Five from Šumiac were sent back, they were no good at it.

So show me.

So I show her.

The bonnet is fully assembled and firm. She is happy.

Not bad for a first try.

She says, and shows me two new bonnets she has made, one of them for herself. She's gone for her annual cardiology check-up in Banská Bystrica, that's as far as she can get these days. And as a folk costume wearer she has the duty to *represent.*

She pulls out a piece of card from her bonnet and adds it to mine to help it keep its shape.

The ritka, the stiffened part at the back, is a bit too wide but never mind, the main thing is that it should stay on my head.

I could have sewn on more trimmings, but *we can always add those some other time.*

Acknowledgements

The translators, publisher and I wish to thank Ivana Šáteková for designing the map on p. *vii* and Jaroslav Beránek for the permission to use the photograph by Irena Blühová as the front cover image.

I am grateful to Jana Ambrózová who inspired this book: she sometimes wears Telgárt folk dress, and introduced me to Iľka, as well as to the Marget sisters and their mother, another vital link.

Jana Ambrózová also has my gratitude for reading this book. Others who have read the manuscript at key points include Radoslav Passia, Marta Součková, Miroslava Vallová, Marko Škop, Alexander Balogh, Marcela Škultétyová and Zuzana Šeršeňová. My thanks to all of them for sharing their views and valuable comments with me.

I thank my husband and daughter for accompanying me along this road. And it is thanks to Milan, Anna and Alena that we keep returning to Šumiac.

But above all, my heartfelt thanks go to dear Iľka for welcoming me and for being such a generous teacher.

Notes

PAGE 1 | **Roma / Romani people (formerly known as Gypsies):** Numbering around half a million and making up an estimated 10 per cent of Slovakia's population, the Romani people are the second-largest ethnic minority in the country. They suffer from institutionalized racism, high unemployment rates and poor housing.

PAGE 2 | **Šumiac:** A village in central Slovakia in the foothills of Kráľova Hoľa with a population of some 1,300 people. Although located just under 300 kilometres north of the capital Bratislava, less than three hours' drive away, the journey by public transport can take many hours and involves several changes of trains and buses.

PAGE 2 | **Ruthenians:** An East Slavonic ethnic group speaking a language closely related to Ukrainian and inhabiting mostly the border regions of the Carpathians between Ukraine, Poland and Romania as well as the easternmost parts of Slovakia, some 200 kilometres east of Šumiac. (The most famous person with a Ruthenian background was Andy Warhol, whose mother was born in the town of Medzilaborce, which now boasts a museum of modern art featuring some of his works.)

PAGE 2 | **An ethnic Ruthenian enclave:** Except for the country's southern region, most of Slovakia's territory is mountainous, featuring a number of ranges from the Lesser Carpathians (peaking at 768 metres) through the Malá Fatra, and the Low Tatras (its highest mountain, Ďumbier, reaching 2,046 metres) through to the high-altitude High Tatras (its highest peak, Gerlach, reaching 2,655 metres).

PAGE 2 | **Kráľova Hoľa:** The highest mountain (1,946 metres) in the eastern part of the Low Tatras. It frequently features in Slovak folklore and romantic poetry. Its peak affords a panoramic view of the Low Tatras and many other mountain ranges, and in good visibility all the way to Hungary.

PAGE 2 | **Hron:** Slovakia's second longest river is one of four rivers springing forth at the foot of Kráľova Hoľa. It flows into the Danube near the border with Hungary.

PAGE 4 | **folk costume:** Until the nineteenth century, people in rural areas of Slovakia used to dress in folk costume. In the course of the twentieth century, wearing the folk costume became increasingly rare, relegated primarily to folk dancing shows and museums, although a steadily dwindling number of women in some areas still dress in folk costume on Sundays and, exceptionally, every day.

PAGE 6 | **Becherovka:** A traditional Czech herbal liqueur.

PAGE 31 | **Pavel Hrúz** (1941–2008): A Slovak writer and poet who was politically persecuted following the Soviet-led invasion of Czechoslovakia in August 1968.

PAGE 32 | **Klára Jarunková** (1922–2005): A Slovak writer, especially of children's books, born in Červená Skala, the village next to Šumiac.

PAGE 49 | **Jozef Gregor-Tajovský** (1874–1940): A Slovak writer, playwright and essayist.

PAGE 57 | **Gadjo / gadhi:** A term used by the Roma to refer to non-Roma people.

PAGE 79 | **Andrej Sládkovič** (1820–72): A Slovak writer, poet and key representative of Romanticism in Slovak literature.

PAGE 83 | **Gorals:** An ethnic group on the Polish–Slovak (and Polish–Czech) border, speaking a dialect which combines regional varieties of Polish, Slovak and Czech.

PAGE 84 | **Wallachian (or Vlach) colonization:** A reference to the migration of Romance-languages-speaking populations from Southern to Northern Europe which took place from the thirteenth to the seventeenth century. It is often associated with shepherds, who brought sheep farming to Slovakia, along with a number of related terms such as *bača* (sheep farmer), *valach* (shepherd), *bryndza* (ewe's cheese), *salaš* (shepherd's cottage) and *fujara* (a long flute).

PAGE 89 | **informal** *you* . . . **formal** *you*: The Slovak language has two second-person pronouns: familiar or informal (ty) and respectful or formal (*vy*).

PAGE 92 | **Ján Slota** (1953–): A Slovak politician, chairman of the Slovak National Party and former mayor of the town of Žilina in northern Slovakia, infamous for incendiary remarks such as 'the Slovaks ought to take to tanks and level Budapest' or 'the thieving Gypsies should be sterilized'.

PAGE 93 | **Jozef Tiso** (1887–1947): A Slovak Catholic priest and politician, he was president of the Nazi-allied Slovak Republic from 1939 to 1945 and was executed as a war criminal after the war.

PAGE 93 | **Jan Šverma:** (1901–44): A Czech communist journalist who lost his life in the Slovak National Uprising against the Nazis in 1944. He was hailed as a national hero, the village of Telgárt being renamed Švermovo in his honour after the war before reverting to its original name in 1990.

PAGE 105 | **Hungarians / Magyars:** The largest ethnic minority in Slovakia, living in the country's south and numbering just under half a million, making up around eight per cent of the total population.

PAGE 131 | **normalization:** The term covering the period following the suppression of the Prague Spring and the Soviet–led invasion of Czechoslovakia in August 1968 and lasting until the Velvet Revolution in November 1989.

PAGE 146 | **Maša Haľamová** (1908–95): A Slovak writer, poet, translator and author of children's books.

PAGE 146 | **Ján Buzássy** (1935–): Acclaimed contemporary Slovak poet and translator.

PAGE 152 | **Karel Jaromír Erben** (1811–70): A Czech historian and archivist, collector of folk songs and fairy tales and Romantic writer, known primarily for his collection of ballads *Kytice z pověstí národních* (A Bouquet of Folk Legends).

PAGE 155 | **the people again voted for a fascist as regional governor:** A reference to Marián Kotleba (1977–), a far-right, neo-Nazi nationalist Slovak politician, referred to in the text as the fascist regional governor, who rails against the European Union and has often disparaged the legacy of the 1944 Slovak National Uprising, centred in the Banská Bystrica region. Paradoxically, in 2013 he was elected governor of the Banská Bystrica region with the help of voters from local villages, many of whose parents had fought or died in the Uprising.

PAGE 157 | **Alexander (Šaňo) Mach** (1902–80): A Slovak journalist and politician, regarded as the 'architect of Slovakia's Holocaust', who served as the Minister of the Interior during the war in the Hitler-allied Slovak Republic.

PAGE 198 | **Borovička:** A traditional Slovak distilled spirit flavoured with juniper berries, similar to gin.